# The Ethics of Sustainable Communication

Simon Cottle
*General Editor*

Vol. 28

Ulrika Olausson

# The Ethics of Sustainable Communication

## Overcoming the World of Opposites

PETER LANG

Lausanne • Berlin • Bruxelles • Chennai • New York • Oxford

**Library of Congress Cataloging-in-Publication Data**

Names: Olausson, Ulrika, author.
Title: The ethics of sustainable communication: overcoming the world of opposites / Ulrika Olausson.
Description: New York: Peter Lang, [2023] | Series: Global crises and the media, 1947-2587; vol. 28 | Includes bibliographical references.
Identifiers: LCCN 2023005499 (print) | LCCN 2023005500 (ebook) | ISBN 9781433197321 (hardback) | ISBN 9781433197291 (paperback) | ISBN 9781433197307 (ebook) | ISBN 9781433197314 (epub)
Subjects: LCSH: Communication—Moral and ethical aspects. | Sustainability. | Mass media and the environment.
Classification: LCC P94. O375 2023 (print) | LCC P94 (ebook) | DDC 302.23—dc23/eng/20240413
LC record available at https://lccn.loc.gov/2023005499
LC ebook record available at https://lccn.loc.gov/2023005500
DOI 10.3726/b20669

Bibliographic information published by the **Deutsche Nationalbibliothek**.
**The German National Library** lists this publication in the German National Bibliography; detailed bibliographic data is available on the Internet at http://dnb.d-nb.de.

Cover design by Peter Lang Group AG

ISSN 1947-2587 (print)
ISBN 9781433197321 (hardback)
ISBN 9781433197291 (paperback)
ISBN 9781433197307 (ebook pdf)
ISBN 9781433197314 (epub)
DOI 10.3726/b20669

© 2023 Peter Lang Group AG, Lausanne
Published by Peter Lang Publishing Inc., New York, USA
info@peterlang.com - www.peterlang.com

All rights reserved.
All parts of this publication are protected by copyright.
Any utilization outside the strict limits of the copyright law, without the permission of the publisher, is forbidden and liable to prosecution.
This applies in particular to reproductions, translations, microfilming, and storage and processing in electronic retrieval systems.

This publication has been peer reviewed

How compact your bodies are.
What a variety of senses you have.
This thing you call language. Most remarkable.
And you *depend* on it. Very much.
But is anyone of you really its master?
But most of all, the aloneness!
You are so alone!
You live out your lives in this shell of flesh.
Self-contained
Separate
How lonely you are!
How terribly lonely.
Star Trek, the original series, S3E5

# Contents

| | |
|---|---|
| *Series Editor's Preface* | xi |
| References | xiii |
| *Author's Preface: An Integral Approach* | xv |
| References | xvii |
| Introduction | 1 |
| The Fundamental Trust | 4 |
| Finding Communion in Communication | 9 |
| The Aim of the Book | 13 |
| References | 14 |

1  Presence 17
   The Ego and the Self 18
   Communication Without Goal 18
   The Metacommunication Inside our Heads 20
   The Wisdom Within 21
   References 23

| 2 | Silence | 25 |
|---|---|---|
| | Deep Listening | 26 |
| | References | 27 |
| 3 | Compassion | 29 |
| | The Illusion of Perfection | 30 |
| | The Deceptive Victim | 32 |
| | Compassion Without Boundaries | 34 |
| | References | 38 |
| 4 | Generosity | 41 |
| | Giving and Receiving | 42 |
| | The Old Ladies and the Beggars | 45 |
| | References | 46 |
| 5 | Open-Mindedness | 47 |
| | Ascribing Objects Meaning | 48 |
| | Ascribing People Meaning | 49 |
| | References | 52 |
| 6 | Defenselessness | 55 |
| | Judgment and Attack | 56 |
| | Cause and Effect | 59 |
| | Guilt and Forgiveness | 61 |
| | References | 65 |
| 7 | Truth | 67 |
| | Different Kinds of Knowledge | 67 |
| | The Absolute Truth | 69 |
| | The Lie | 71 |
| | Consistency and Authenticity | 73 |
| | Observations and Emotions | 74 |
| | Unveiling the Ego | 76 |
| | References | 78 |
| 8 | Joy | 79 |
| | Disarming the Ego with Humor | 82 |
| | Choosing Joy | 83 |
| | References | 84 |

| | | |
|---|---|---|
| 9 | Acceptance | 85 |
| | Surrendering to What Is | 85 |
| | Merrily, Merrily, Merrily … | 87 |
| | References | 89 |
| 10 | Sustainable Communication and Deep Sustainability | 91 |
| | Deep Sustainability | 92 |
| | Communication Beyond Language | 99 |
| | Love as Deep Sustainability | 102 |
| | References | 106 |

*Afterword*     109

# Series Editor's Preface

As series editor it is a pleasure to say a few opening words about Ulrika Olausson's *The Ethics of Sustainable Communication: Overcoming the World of Opposites*, and its contribution to the Global Crises and Media series. Over the course of the series and more than 25 volumes, it has become increasingly apparent how the contemporary world (dis)order not only spawns distinct or separate global crises but is now itself, holistically, in terminal crisis. Global crises represent the dark side of our globalized planet. Their origins and outcomes are not confined behind national borders, and they are not best conceived through national prisms of understanding. Their impacts register across "sovereign" national territories, surrounding regions and beyond, and they can also become subject to systems of governance and forms of civil society response that are no less encompassing or transnational in scope and ambition. In today's interdependent world, global crises cannot be regarded as exceptional or aberrant events only, erupting without rhyme or reason or dislocated from the contemporary world (dis)order. They are *endemic* to the contemporary global world, deeply *enmeshed* within it and potentially *encompassing*. And so too are they highly dependent on the world's media and communication networks.

Today multiple global crises also compound and enter into each other, and in ways that pose existential threats to the continuation of life on planet Earth.

Without fear of hyperbolism, we can say that we are living in a *world-in-crisis*. Multiple existential threats now converge and bear down on the planet's biosphere and all life on earth. These can be traced for the most part to human society and its predominant economic system premised on incessant—unsustainable—growth and a corresponding worldview of human exceptionalism (speciesism) and materialist presumptions of progress.

Human civilization is confronting the possibility, some say distinct probability, that it is now in its endgame. Existential threats include not only climate change and nuclear weapons, but biodiversity loss, the sixth mass extinction, zoonotic pandemics, ecological degradations, food, water and energy insecurity and soil depletion, among others. These are all deeply entwined in today's planetary emergency. Forced migrations, faltering supply chains, and financial crises further exacerbate and express these existential threats and prove fertile grounds for the rise in polarized politics, authoritarianism and propensities for conflict and war.

Today's "world civilizational community of fate" (Beck, 2006), evidently, is confronting a host of systemic and deeply entangled existential threats that cascade and unfold in complex interaction, many of them registering in the world's eco-systems and biosphere. How today's global crises become variously communicated proves critical to their subsequent trajectory and their reverberations around the world, as well as in pathways of mitigation or adaptation into the future. This has often formed the focal point of many of the volumes and contributing authors to this series.

Ulrika Olausson's *The Ethics of Sustainable Communication: Overcoming the World of Opposites* approaches concerns of communication against the backdrop of today's planetary emergency from a different or more oblique perspective. In doing so, new insights and new ways of apprehending the positive value and possibilities of communication in a crisis-ridden world are brought into sharper relief. Ulrika Olausson invites us to momentarily step back and take time out from the established academic preoccupations with media, representation, and language in terms of identity, power and meaning, and to quietly reflect on the nature of communication itself and how this could yet become a communicative foundation for a deeply sustainable world. In this sense her book can be read as a contemplative deep dive into "understanding and using communication," and with the express intention, as she says, "to transform structural patterns of fear, lack of trust and experience of separation, into peace of mind as well as a sense of belonging and trust in each other and in our social and natural environments." In today's crisis-ridden world, characterized by increasingly polarized and fractious

politics as well as the epistemological fracturing of certainty and trust in institutions and public discourse, this approach is both timely and hugely promising.

Through a series of contemplative chapters on the nature of communication and its possibilities, Olausson elaborates nine ethical principles for *sustainable communication*. That is, a communication ethics that is better suited to the development and conduct of communication that is oriented to an interconnected and interdependent world. A world in which human beings must begin to see themselves as part of the web of life, and not as outside, separate from or above it. This, as a growing number of voices around the planet are beginning to advocate, is the only way that human society can begin to move beyond the ecological devastation that we have caused to the very fabric of life on planet Earth and find a sustainable and symbiotic way of living into the future. In this and in other philosophical respects, this book and its communication ethics chimes not only with the climate and ecological backdrop of today's planetary emergency, but also the growing awareness and appreciation of spiritual and indigenous traditions that have long provided less egocentric and materialist, and more relational and spiritual perspectives on human life and the interdependencies of being.

This embrace of non-dualistic thinking and traditions outside of the usual academic canon is both welcome and often enlightening. Here it helps to crystallize the value of a communication ethics that is particularly well suited to address the deep-seated problems of human separation, alienation, and loss of trust that Olausson argues fundamentally underpin today's planetary emergency as well as our, so far, generally inadequate responses to this. *The Ethics of Sustainable Communication: Overcoming the World of Opposites* provides a rich seam of ideas with which to begin to think through how communication can and should be enacted in pursuit of a sustainable future for all life on planet Earth. This is a welcome and necessary invitation and one that implicitly carries a message of possible hope in a world of growing uncertainty and precarity. It is also a message that is destined, sadly, to become increasingly pressing and much needed in the years ahead.

Simon Cottle

# References

Beck, U. (2006). Cosmopolitan Vision. Cambridge: Polity Press.

# Author's Preface: An Integral Approach

I used to think the top environmental problems were biodiversity loss, ecosystem collapse and climate change.
I thought that with 30 years of good science we could address those problems.
But I was wrong.
The top environmental problems are selfishness, greed, and apathy … and to deal with those we need a cultural and spiritual transformation—and we scientists don't know how to do that.

The quote above, commonly attributed to Gus Speth, clearly illustrates my own motivation for writing this book. I had been scientifically active for 25 years and came to a point when I realized that for addressing the massive sustainability problems the world is facing, science is not enough. Had that been the case, these problems would have already been solved. No, there is quite simply a need for something more; a radical transformation of a cultural and spiritual nature—a paradigm shift (as difficult and controversial as it may be)—just as the opening quote suggests.

But what is missing in modern science, then? The question is ultimately about how aspects that were obvious to premodern science, in particular the existence of a non-material yet very "real" reality, could be replaced by materialism and reductionist empiricism. In the book *Integral Psychology*, Wilber (2000) argues that when modern science delimited reality to consist of matter only, its explanatory power was also significantly reduced. Today it can only understand one of the links in a much longer chain which, according to Wilber, includes matter as well as mind, soul, and spirit. What he describes is what Lent (2021, pp. 98–99) labels ontological reductionism, which regrettably has fostered a belief in many scholars that science *is* reductionism. This tendency of academia to reduce what *is* lends evidence to the statement that "much learning means little wisdom" in

the *Tao Te Ching* (ch. 81), which is one of the first classics in Chinese philosophy. Thus, there is a need for integral approaches that connect the material and the spiritual realms: "If there is ever to be … truly … integral studies, this extraordinary rupture between premodernity and modernity—spiritual and material—needs to be confronted head on" (Wilber, 2000, pp. 55–56).

The body of literature applying integral approaches is steadily growing, not least in the fields of ecological philosophy and deep ecology. In the book *The Web of Meaning*, Lent (2021) successfully connects (natural) science with wisdom traditions from all over the world to develop an integrated understanding of the interconnectivity that constitutes reality.

> A defining characteristic of modern *gewu* [investigation, author's remark] would be the recognition that the web of connectivity interpenetrates every aspect of life: from scientific to spiritual, from philosophical to practical, from emotional to political. (Lent, 2021, p. 115, italics in original)

In agreement with ancient Indian wisdom, I would like to add that in an integral approach the material universe cannot be studied as anything other than, or as something separated from, the consciousness that experiences it. The universe is not something to be only observed, because it is a participating universe in constant interaction with the observer. What we need, then, is a knowledge that includes the changing phenomena—the world of form—*and* the constant consciousness—the world of the formless within which all phenomena take their transitory form.

This book, in which I suggest a communication ethics aimed at promoting the experience of interconnectedness, includes on the one hand theories from the social sciences overall with an emphasis on media and communication studies. On the other hand, its point of departure is that of perennial philosophy with deep historical roots and a universalist view of reality, which, simply put, forms the backbone of both Eastern and Western ethical-spiritual culture. Moreover, the book is inspired by the transcendent realities that poets, artists, spiritual teachers, musicians, and writers have always conveyed with their various tools and forms of expression. The integral approach inevitably means that the picture is painted with rather broad strokes. This is the price to be paid when trying to figure out the wholeness instead of its separate pieces (Lent, 2021).

The overriding prerequisite for a sustainable world is that we can live in harmony with ourselves, with our fellow human beings and with all beings with whom we share the planet. For this reason, I have let the ethics speak at the

level of the individual. Because if we cannot even create peace within ourselves, how can we expect to create a peaceful and sustainable world outside ourselves? The expansion of trust that the book wants to stimulate to reduce the prevailing experience of separation, should therefore be seen as a prerequisite also for the well-being of the larger collective. The macro level is addressed primarily in the concluding chapter, where the principles of the ethics are synthesized and conceptualized as *sustainable communication,* serving the development of *deep* sustainability.

<div align="right">Ulrika Olausson</div>

# References

Lent, J. (2021). *The web of meaning: Integrating science and traditional wisdom to find our place in the universe.* Gabriola Island, Canada: New Society Publishers.

Wilber, K. (2000). *Integral psychology: Consciousness, spirit, psychology, therapy.* Boston & London: Shambala Publications.

# Introduction

The single biggest problem in communication is the illusion that it has taken place.[1]

This book is the result of me starting to despair about the value of communication. I, a professor of media and communication studies, had gradually begun to doubt the very practice of communication! On a personal note, I had rarely experienced a conversation that deeply resolved a conflict or truly led to increased understanding. Polarization, more or less open accusations and an underlying drive to, so to speak, win the communicative contest had rather resulted in a deadlock—an increasing distance between us. Just as the introductory quote suggests, I increasingly sensed that communication that creates togetherness and mutual understanding is simply an illusion. A mission impossible.

Today, communication is largely viewed as an instrument to be used for different purposes. In most sectors of society, not least the political, the extroverted and argumentative mode of communication is the norm—to manipulate or defeat opponents with crude wordings or rhetorically clever arguments. Although often aimed at maintaining relationships rather than conveying information (Carey, 1995), everyday communication is not much more constructive. In fact, also this mode of communication largely involves "getting" something from somebody else, even though we are usually not aware of it: "I want attention!" "I want you

---

1 Quote commonly attributed to George Bernhard Shaw.

to feel sorry for me!" "I want you to be impressed by me!" It is also common that communication turns into a competition, where we try to convince each other that our perspectives of the world and interpretations of events are the correct ones. Communication becomes a struggle for interpretative power to define situations, people, and the world at large. The act of listening is sent off to the periphery of attention, and communication turns into a tool for (momentarily) strengthening our egos. In this book, the ego is an important concept and refers to the most rudimentary experience of an "I" that is separated from the rest of creation; the part of us that thinks we are special and unique, not just by being better than others in various respects but often by being worse—victims or losers. The ego is explained in more detail in the next chapter.

Due to the ego's involvement in our social interactions, communication is often turned into a means to get what we want, assert ourselves, defend ourselves, get "more" of something, gain sympathy, and very often simply to be right. It is used as a power instrument to gain success as an individual, as a company, as a politician, as a manager, as an employee, when we more or less intentionally try to influence other people's thoughts, behaviors or beliefs through the images of ourselves and the world around us that we want to convey in different situations. Admittedly, this communication pattern might be described in somewhat exaggerated and instrumental terms here, but the question remains whether communication in a format even similar to this creates harmonious relationships and takes human development in a sustainable and inclusive direction. I doubt it.

Also in my professional work, I grew disillusioned with communication and its potential to contribute to a decent society. For the past decades, my research interest has particularly revolved around global sustainability crises in general and environmental hazards in particular—how, for instance, climate change is communicated and presented in the media, and how it is perceived by people. Environmental communication is important to study because the state of the natural environment is grave to say the least; our civilization is devastating the living Earth on an unspeakably massive scale—climate change, loss of biodiversity, ocean acidification, the ongoing sixth great extinction of species, and deforestation are just a few of the many examples of this.

Regrettably, both my own research and that of others clearly show that despite the overwhelming amount of scientific evidence of, say, the causes of climate change, it is far from certain that people accept such information. For example, if we are used to spending our vacations in Thailand (as many Swedes do) and want to continue doing so, we will probably rather reject or modify information that says that flying has ecological footprints than change our behavior, no matter

how many times and in what formats and channels this information is communicated. Another example is meat consumption. If meat is an integral part of our diet, we would probably rather reject information about the environmental and health impacts of meat than change our established eating habits. To avoid cognitive dissonance, that is, the discomfort that arises when what is communicated collides with our own values and behaviors, we find arguments that allow us to maintain our established lifestyle (Olausson, 2018).

In this way, we accept information that confirms our already established opinions and legitimizes our behaviors whereas we reject information that does not. In psychological research, the tendency to selectively choose information that suits ourselves is called *confirmation bias*. There is usually no logic behind these tendencies, which means that we can simultaneously accept the general features of climate science, for example, that climate change exists and is largely human-made, and dismiss more specific scientific knowledge about, for example, its causes when it interferes with our established lifestyle (Olausson, 2019).

These are not new findings in communication research. It is well established that communication does not work linearly in terms of a simple transmission of information from sender to receiver. The recipients of a message always filter it through their own mental "schemas," formed by individual and collective experiences, attitudes and values, and might therefore ascribe at least partly new meaning to the information (Hall, 2010). Nonetheless, it seems as if this rejection of (scientific) information, no matter how often and in what channel it is communicated, has increased in scope in recent times. This hypothesis is strengthened by the new words of past years, such as Oxford Dictionary's designation of "post-truth" as the word of 2016. Instead of relying on scientists or other experts regarding issues pertaining to society and nature, we allow our personal beliefs, everyday experience and emotions provide us with information. We assess this subjective knowledge to be of as high quality as the knowledge that science produces and communicates, or even higher.

The use of so-called "alternative facts," that is, information that is not systematically verified and without reliable sources, has followed as a natural consequence of this trend. The same applies to one of the Swedish new words of 2015, "fact resistance," which means that (scientific) knowledge is rejected if it conflicts with our personal opinions, our own worldview, and the "alternative facts." This resistance to facts is often based on some kind of conspiracy theory, for example, that the social elite—the "establishment"—has a hidden agenda and wants to obscure other, more serious but economically sensitive environmental problems.

This is allegedly done by shifting focus to information about the environmental harm of, as cases in point, flying or meat eating (Olausson, 2018).

Contemporary society is thus characterized by serious communication problems both at the interpersonal and the societal level. I interpret these problems as intimately connected with a significant *lack of trust*, both in relation to other people and to life in general. We feel distrustful toward the intentions, goodwill and credibility of each other and our institutions, and instead of trust, a widespread insecurity—produced and reproduced in aggressive or defensive words—has emerged. In this manner, we come full circle, as this rather taken-for-granted way of communicating insecurity both has its starting point in and reinforces the fundamental lack of trust. All of this, of course, constitute poor conditions for harmonious relationships and a sustainable world. Polarization is increasing, conflicts are frequent, and many people suffer in their family relationships, in the workplace and in society at large.

## The Fundamental Trust

Now, what is the reason for the lack of trust? Of course, there is no simple answer to this question, and we have to go very far back in time to find its roots. One significant reason can, however, be found in the disrupting development that has been going on for several decades, characterized by individualist thinking, ruthless exploitation of nature, competition as the norm and increasing gaps between rich and poor, politics and citizens, urban and rural etc. This development has created economic and social prosperity for some people, but at the same time accentuated a profound sense of *separation* in all of us; that we do not belong with each other, and we do not belong with nature. Instead, we experience ourselves as isolated and distant islands lost in a completely unpredictable existence, where threats from anywhere seem to emerge. At the societal level: "The entire system is collapsing!" At a personal level: "That person doesn't seem to like me much!" And in relation to nature: "Climate change is the end of humanity!" The whole world becomes crazily complex with an endless series of conflicts and seemingly unsolvable problems, which gives rise to "an epidemic of loneliness sweeping the world," in the words of Monbiot (cited in Lent, 2021, p. 219). The Star Trek quotation that opens this book precisely illustrates this feeling of separation and loneliness, which the highly advanced lifeform Kollos experiences when temporarily inhabiting Mr. Spock's body. We are so terribly lonely!

Even though we do not always perceive it, the experience of separation, loneliness, and lack of trust is intimately linked to the emotion of fear. In Eastern wisdom, all emotions are traced back to two basic ones, namely love and fear, and several of today's sociologists have described contemporary society precisely as fearful. For example, Bauman (2006) describes in the book *Liquid Fear*, a notable fear and anxiety that permeate modern society. He suggests that this fear is due to the uncertainty we feel about our ability to determine what the threats are, where they come from and when they may appear. Furedi (2006) says in his book *Culture of Fear* that we have created catastrophic images of the state of the world and the presence of threats in our lives through the rapid development of communication technologies, which in many ways has caused both time and space to seemingly shrink.

Not least traditional journalism constantly contributes to this contagious fear and the experience of widespread threats. Their focus on negative and dramatic events in their news evaluation has a long history and, sadly, they show no signs of changing. The advent of so-called alternative media online, whose "journalistic" product is based on a highly polarized view of reality, has not rendered the threats less prominent. Unfortunately, many people, who either feel misrepresented or not represented at all in legacy media, are more or less forced into these fora. The alternative (often right-wing) media offer inclusion and acceptance to those people who for various reasons distrust the "establishment" and find themselves positioned in what Hallin (1986), in his well-known typology of traditional journalism, describes as the "sphere of deviance." In contrast to the "sphere of consensus" and the "sphere of legitimate controversy," the people in the "sphere of deviance" are either excluded from the news agenda or demonized and assigned the role of scapegoat.

In the digital mediascape with its rapid and widespread dissemination of information, propaganda, misinformation, and conspiracy theories with different political and polarizing purposes proliferate. Before the advent of especially social media, traditional media were the main targets of propaganda and misinformation, and professional journalists acted as gatekeepers, that is, they did (with varying quality) the fact-checking and decided what to report as news. In the digital ecology, however, with its abundance of information, each of us must be our own gatekeepers, which means that everyone has to be capable (and willing) to assess the quality of information and sources.

The development of social media has, on the one hand, contributed opportunities to be social and create communities, but on the other hand, with their enormous reach and impact they also constitute excellent fora for the amplification of

threats and polarization toward the "others." Media scholars have pointed to the dangers of, for example, potential echo chambers (Yusuf, Al-Banawi, & Al-Imam, 2014), that is, closed groups of likeminded people online. Since such groups lack dissident voices, the knowledge claims made here "echo" largely unchallenged back and forth. A similar phenomenon is filter bubbles (Pariser, 2011), which take shape when what we see online is controlled by algorithms based on our previous clicks and digital behaviors. This means that we only get exposed to the same type of information that we once targeted. In the age of digitalization, we are thus becoming increasingly isolated from each other, and the fear and lack of trust grow increasingly stronger. We perceive ourselves as separate entities in an extremely insecure and erratic world.

The causes of fear, the feeling of separation and the lack of trust are in this way structural; they are built into the very systems of society, and we as individuals have no real control over them. At the same time, each of us carry these structures in our thought systems. When we in thought separate Me from You, Us from Them, Evil from Good or Human from Nature, and turn these thoughts into words in communication, the structures continue to exert influence over us. For example, when we talk about humans as something separate from non-human lifeforms, we reproduce this separation through our established ways of communicating. The same applies when our communication is based on an (imaginary) group identity, for example, the national identity, and we in this way separate ourselves from the identity groups that do not seem to meet the criteria for this in-group (Olausson, 2005).

With this type of communication, we reproduce—without really being aware of it—the fear, the lack of trust and the devastating experience of separation; we allow ourselves to be caught in dualistic thinking, which means that everything must have an opposite, and this becomes excellent soil in which the experience of separation can grow further. A world of differences, contrasts and contradictions is thus reconstructed through our use of language. And regrettably, we communicate almost *all the time* in this dualistic and separating way, using words we learned as children, are used to, and would never dream of questioning. The very grammar in our language, which requires a subject and an object to complete a whole sentence, contributes to reinforcing a mode of communication that feels completely natural and neutral, but which in fact consolidates conditions that need transformation.

But it does not have to be that way. Yes, the reasons for the lack of trust are mainly structural—they are deeply embedded in the structures of society and culture—but we as individuals are not powerless or incapable of contributing

to change. In the social sciences, the concepts of *structure* and *agency* are used to make visible and problematize the dialectics between structural conditions and the possibilities for individuals to influence them (Berger & Luckmann, 1966). Of course, communication on the one hand can consolidate and nurture separating social structures, as the unconscious and unreflected communication does—in this way the structures are dominant. But communication also has the remarkable potential to contribute to change, and this is where we find the power of agency.

In the same way that language and communication are shaped by our society and culture, society and culture might also be revitalized and transformed by communication (Fairclough, 1995). This means that even though the experience of separation is structurally conditioned—built into language—we can break free from it by not considering the dualistic thinking and communication as self-evident and inescapable. The critical-theory inspired strands of sociolinguistics and communication studies argue that the exercise of power is the most successful when it takes the form of naturalized—taken-for-granted—meaning (Hall, 1995). Exercise of power through violence or coercion is visible, easy to identify and therefore possible to resist, but naturalized meaning in language is more difficult to discern and constitutes a form of covert exercise of power. It is covert, because the power relations are reproduced by people themselves when they communicate on "autopilot," as it were (Gramsci, 2000).

As a case in point, not so long ago it was regarded and communicated as something "natural" that only men should have the right to vote, which reproduced and nurtured the patriarchal power structures. As long as these relations were taken as empirically given facts, transformation toward gender equality was not possible, but as soon as people started to explicitly question these established and naturalized assumptions, things started to happen. Thus, in order to free ourselves from the structures in which language holds us trapped, we must examine, question, and, so to speak, "denaturalize" it (Machin & Mayr, 2012).

We find similar reasoning in Hindu wisdom, which speaks about what in Sanskrit is called *shraddha*, that is, the rarely questioned—naturalized—and therefore extremely potent beliefs that we live our lives by. *Shraddha*, in the form of unconscious thinking and communication of taken-for-granted meanings, determines how we will see and understand both ourselves and others, as well as what we experience as the world around us. "… There is nothing passive about shraddha. It is full of potency, for it prompts action, conditions behavior, and determines how we see and therefore respond to the world around us" (Easwaran, 2007a, p. 63).

This naturalized belief system thus determines *where* we place our trust and confidence. In the global market economy, for example, we have basically placed our confidence in the market forces—that economic competition will create the good society and prosperity for the many. However, this assumption has with full clarity proved to be incorrect and also caused the unsustainable development, both in social and environmental terms, of which we today see the evident consequences. In the belief and trust in the "magic of the market," the real delusion, *moha*, which is its Hindu label, is manifested. This delusion entails "self-centered attachment" (Morrison, 2007, p. 150), which means that we are completely attached to our own desires and results in constant differentiation toward the "other," merciless competition and disruptive greed (Lent, 2021). When these characteristics become institutionalized, as they have in contemporary neoliberal order, they inevitably lead to sustainability disaster as illustratively pointed out already in one of the first classics of Chinese philosophy, the *Tao Te Ching*:

> When the desires ... are reinforced by access to political power: greed; envy, lust for glory and the wish for one ego to triumph over another generate war and all the evils that come with it. (Wilkinson, 1997, p. xvii)

Similarly, in *The Perennial Philosophy*, Huxley (1945/2009, p. 81) states that power, prosperity, and reputation come at the cost of "an ever completer inability to escape...from the stifling prison of selfness and separateness," and that nemesis *always* follows hubris.

In order to escape *moha* and the fearful experience of separation that it triggers, we need to start denaturalizing the destructive oppositional beliefs as well as their communication, that is, stop taking them for granted. Once we have started to critically examine our own naturalized preconceptions of, and communication about, various seemingly oppositional phenomena and relationships, we will discover that our perception of them also gradually changes. This is how we set the stage for trust to take root. In chapter 3, I will give more concrete examples of such a denaturalization of thought and language.

In sum, this book is about understanding and using communication to transform structural patterns of fear, lack of trust and experience of separation, into peace of mind as well as a sense of belonging and trust in each other and in our social and natural environments. The threats to the living Earth have never been greater, and as Cronon states (1996, p. 22), "to protect the nature that is all around us, we must think long and hard about the nature we carry inside our heads." As we build the communicative foundation for a deeply sustainable

world, we increasingly approach the essential realization that the perceived separation, feeling of loneliness and alienation from others are in fact nothing more than flawed sense perceptions and dualistic thoughts. The idea of separation does not represent reality—it is a product of a long-standing oppression in a surface world of opposites. This will be further developed in the next section.

## Finding Communion in Communication

To return to my own story about how this book came into existence, I refrained from resigning completely, even though for a while I felt really disillusioned about the potential of communication. Instead, I started to think about how our view of communication and our ways of communicating could be revitalized toward greater awareness and trust. If the communicative shortcomings I had experienced around me were basically due to the experience of separation and the lack of trust in each other and the outside world, then the obvious role of communication would be to restore these necessary conditions. This conclusion may be appealing in its perhaps somewhat naive simplicity, but it does require the existence of a deeper dimension of communication, which is capable of promoting togetherness and trust; a dimension that is neither covered by the scientific communication models with their different focus on communication as "transmission," "ritual," "relationship," "meaning-making," and so forth (McQuail, 2010), nor by the practical handbooks that often take their points of departure in an utterly simplified understanding of "effective" or "successful" communication.

In order to identify the more basic dimension of communication, I went back to the etymology of the word, that is, to its origins. Obviously, as a communication scholar, I am fully aware that the term originates from the Latin word *communicare*, which means "to make common." But this time, I noticed something different with the etymology, something I had not recognized before, namely the little word "make." Thus, according to this definition, communicating means an active "making" of the common (*communis*), which implies an underlying assumption that this "common" does not already exist but has to be created through communication.

However, if we reflect upon this for a moment, we realize that there is nothing in this communicative "making" of the common that guarantees trusting and harmonious relationships. It is true that some form of agreement may arise through the making of common meaning, but this agreement could just as easily be the result of communicative oppression as of shared understanding; that

someone, through their access to the argumentative tools, simply imposes their opinion on somebody else. If you have forced your opinion on me because you have "won" the argument, we have certainly "made" your particular interpretation common, but hardly in a way that builds trust and harmonious relationships. Instead, the communicative act probably rather reinforced the experience of separation and divergence.

Thus, communication in the sense of *making* common does not work satisfactorily. But if we instead attempt to *find* the interrelationships (*communion*) that are already common, the conditions for reducing the experience of separation radically improve. The purpose of communication would then be to *commune*, that is, to identify these already existing connections. This would be something radically different from the ego-centered communication we are used to, where we—through our thinking minds in more or less aggressive or manipulative ways—strive to make meanings common. As Tolle explains (2011, pp. 105–106), "most human relationships consist mainly of minds interacting with each other, not of human beings communicating, being in communion."

In sum, the assumption of finding—not making—the common, is the cornerstone of the communication ethics suggested here. When *communing*, we do not want to manipulate, control, convince, compare, defend, dominate, perform, or win, but simply facilitate harmonious relationships everywhere and at any time by scaling up trust and scaling down separation.

The ethics is thus rooted in a holistic view of reality (*ontology*), which means that everything that exists, including humanity, is connected and that everything is part of a larger whole. This suggests that our innermost being—that with which we came into this world, or, in other words, that which existed before we assembled the many ideas about ourselves and shaped our egos—is shared and inherently one.

> All human beings are at the deepest level essentially the same, therefore there must be a fundamental knowledge of ourselves that transcends the local, temporal conditioning that we acquire from our cultures and thus share with all humanity, irrespective of our political, religious or ideological persuasions. (Spira, 2017, p. 4)

This integral ontology is on an overall level inspired by perennial philosophy with deep historical roots and a universalist view of reality, which, simply put, forms the mystical core of all the world's great religions. The basic message of perennial wisdom is that they all ultimately point to the same absolute Truth—that

everything is One, not in a metaphorical sense but entirely literally—even though on the surface they seem to differ (Huxley, 1945/2009). As Easwaran (2007b, p. 22) notes, the main message of the Indian Vedic texts of the *Upanishads* is the notion of oneness, which constitutes the "wellspring of all religious faith" and is revealed through direct (mystical) experience. This ontology of *nonduality* is perhaps most evident in *Advaita Vedanta*, which is one of the oldest schools of Indian philosophy. *Advaita* is composed by two Sanskrit words: "A-," meaning "non-," and "Dvaita," meaning "duality," in sum, "non-duality."

The nondual ontology is also found in modern eco-philosophical thought, for example in deep ecology (e.g., Abrams, 1997; Macy, 2021; Macy & Johnstone, 2012; Naess, 2016), where all life is considered as entwined in a seamless whole. A simple comparison would be the physical phenomenon of quantum entanglement, which means that particles are entangled with each other to the extent that what happens to one particle also affects the other particles regardless of distance. Alain Aspect, John Clauser, and Anthon Zeiliger were rewarded the 2022 Nobel Prize in physics because of their groundbreaking research about this phenomenon.

The prize winners' insights into the conundrum of quantum entanglement entirely supports the ancient wisdom of the East, where reality is regarded as an eternal, infinite, indivisible whole, whereas the multifaceted, finite, contrasting and fragmented reality that we tend to perceive is viewed as illusory. Not illusory in the sense that it is not real but that it, through our rather flawed and limited perception, appears as something that it is not. Instead of perceiving it as different expressions, shapes, and colors of the indivisible whole, we experience the world as constituted by separate and isolated phenomena with different forms and different names.

But this illusory world that we perceive with our senses represents the separating structures of the mind itself rather than any objective reality. All the mind perceives is a reflection of its own limitations (Spira, 2017). Easwaran (2007a, p. 29) in the *Bhagavad Gita* explains this so-called *maya* illusion like this:

> The world of "name and form" exists only as a condition of perception; at the subatomic level, separate phenomena dissolve into a flux of energy. The effect of maya is similar. The world of the senses is real, but it must be known for what it is: unity appearing as multiplicity.

The communication ethics proposed in this book rests on the epistemological assumption that dualistic thinking and communication reproduce the *maya*

illusion, that is, that the ways in which we think and communicate knowledge (*episteme*) about the world, maintain the belief in separation. Simply put, duality prevents us from experiencing All as One, and could therefore be described as a tyrannical structure, as it obscures our vision and keeps us oppressed in an illusory world of opposites. Duality captivates us at a lower level of consciousness, which also implies the lower—illusory—level of reality. By practicing the ethics suggested here, we seek to raise the level of consciousness by overcoming the world of opposites and instead communicate from our shared essence—the union of all life in One.

If these ontological and epistemological premises seem overly abstract and difficult to grasp, perhaps the parable of the sun and its rays can be helpful (Tolle, 2011). Through human perception, it is obvious that all sunrays are linked through their common essence, the sun itself. But what if the sunrays do not perceive this but instead see themselves as separate entities and start looking at each other with distrust and fear? The same goes for the sea and its waves. We humans clearly perceive that all waves are connected through their shared essence, the deep sea. But perhaps the individual wave does not recognize this, but fearfully envisages a lonely journey toward land and its dissolution. In the same way, it is reasonable to assume that human perception is not perfect either, and that we as well are linked through a common essence, which we cannot (yet) comprehend. If the sunrays knew about their interconnection through the sun, they would not distrust each other. If the sea waves knew about their connection through the sea, they would not be afraid. And if we were aware of the connection with our shared essence, we would not experience separation, lack of trust, and alienation toward each other and our environment.

The core of the communication ethics proposed here is simpler than its ontological and epistemological premises. It consists of the most fundamental elements of all human interaction, such as telling the truth, being compassionate and open minded. However, it seems as if such basic communicative elements have been replaced by more complex ideas about communication as, for example, an infinitely complex series of meaning-making processes (e.g., Saussure, 1959) and I–You/Thou relationships (Buber, 2013). Such theories are certainly valid, but they are often regarded as too complicated to be really understood and applicable to everyday life. The opposite also exists in the form of strategic but often reductive ideas about communication, where the goal is rational information transmission from sender to receiver. Somehow, we seem to have forgotten that it is the most basic elements that possess the greatest power and potential to transform deep-going structures.

## The Aim of the Book

In the following chapters, nine ethical principles for *sustainable communication* are proposed, all of which are intended to reduce the prevailing experience of separation and instead stimulate the expansion of trust. They are not meant to establish an ethical-spiritual doctrine but to serve the purpose of lasting sustainability—(re)aligning us with each other and with the seamless web to which we all belong (Macy, 1991).

The overriding prerequisite for a sustainable world is that we can live in harmony with ourselves, with our fellow human beings and with all beings with whom we share the planet. For this reason, the ethical principles speak at the level of the individual. Because if we cannot even create peace within ourselves, how can we expect to create a peaceful and sustainable world outside? The expansion of trust and the reduction of separation should therefore be seen as a prerequisite also for the well-being of the larger collective.[2]

The aim of the book is to contribute to a communicative development that stimulates the experience of interconnectedness and union with everything in an indivisible, seamless whole. It outlines a value system that builds on the profound realization of oneness and suggests how these values might be expressed it in the world. This would be one way to unlearn the many misconceptions about reality that we have been socialized into (Lent, 2021). Thus, the book should not primarily be seen as a contribution to an intellectual or theoretical discussion on the constitution or significance of communication, but as a humble yet normative pointer to how sustainable communication can be *lived*. It contains scientifically robust and well-established theories of language and communication as well as empirical research results, but it also rests on a view of reality that includes what is not (yet) empirically observable and scientifically verified. This is entirely logical since one of the book's basic assumptions is that human perception is significantly flawed and leads us into an illusory—dualistic—reality.

Even though the ethical principles are fundamental and uncomplicated, one hardly learns to practice them from one day to the next. It is nonetheless true that each of them is available to us right here and now. In our innermost being, where we find the inherent connections between everything that *is*, we can be nothing

---

2  The individual level thus does not eliminate the responsibility of the political institutions, the industry and other social actors at the macro level. A (communicative) transformation is necessary at all levels of society.

but, for example, true, compassionate, and generous, but we need to carefully cultivate these innate qualities in order for them to grow. Ingrained systems of thought and language, based on structures of selfishness and greed, obstruct their manifestation and structures are always inert. Anyone looking for a communicative "quick fix" will thus be left disappointed. On the contrary, the ethical principles turn many of our habitual communication patterns upside down as well as our established assumptions about the world, ourselves, and other people. As Lent (2021, p. 29) says, "following this path … requires questioning many assumptions of our mainstream worldview and perhaps turning over previously fixed bulwarks of belief." Patience—a virtue that is not highly valued today, when the result of a given effort should preferably manifest immediately—is therefore needed.

It is important to emphasize that we all live under different conditions with different individual and collective life situations that influence the potential for trust to expand. There may be circumstances that we think have to change in order for us to develop the communication ethics proposed here. This does not diminish its validity. On the contrary, the application of the principles in total or in part, might be precisely what generates the power needed for change. However, all words and all communication are potentially controversial, and so are the words in this book. Thus, if you are looking for conflict you may well find this when reading it. But if you seek guidance to stimulate trust and sustainability you will find this as well if you are willing to critically scrutinize some of your taken-for-granted assumptions and established ways of communicating.

Lastly, the ethics does not claim to be exhaustive—there are probably many other ways to communicate trust and pave the way for lasting sustainability. I hope that this book will stimulate such a development. We are all pupils rather than teachers in this process.

# References

Abram, D. (1997). *The spell of the sensuous: Perception and language in a more-than-human world.* New York: Vintage Books.
Bauman, Z. (2006). *Liquid fear.* Cambridge: Polity Press.
Berger, P. L., & Luckmann, T. (1966). *The social construction of reality: A treatise in the sociology of knowledge.* Garden City, NY: Anchor Books.
Buber, M. (2013). *I and Thou.* London: Bloomsbury Academic. (Original work published 1937).
Carey, J. W. (1995). Mass communication and cultural studies. In O. Boyd-Barrett & C. Newbold (Eds.), *Approaches to media: A reader* (pp. 365–373). London: Arnold.

Cronon, W. (1996). *Uncommon ground: Rethinking the human place in nature*. New York & London: W. W. Norton.

Easwaran, E. (2007a). Introduction. In *The Bhagavad Gita* (E. Easwaran, Trans., pp. 7–67). Tomales, CA: Nilgiri Press.

Easwaran, E. (2007b). Introduction. In *The Upanishads* (E. Easwaran, Trans., pp. 13–47). Tomales, CA: Nilgiri Press.

Fairclough, N. (1995). *Media discourse*. London: Edward Arnold.

Furedi, F. (2006). *Culture of fear revisited*. London & New York: Continuum.

Gramsci, A. (2000). *The Gramsci reader: Selected writings 1916-1935*. New York: New York University Press.

Hall, S. (1995). Cultural studies: Two paradigms. In O. Boyd-Barrett & C. Newbold (Eds.), *Approaches to media: A reader* (pp. 338–347). London: Arnold.

Hall, S. (2010). Encoding/decoding. In P. Marris, C. Basset, & S. Thornham (Eds.), *Media studies: A reader* (pp. 28–38). Edinburgh: Edinburgh University Press.

Hallin, D. (1986). *The "uncensored war": The media and Vietnam*. Oxford: Oxford University Press.

Huxley, A. (2009). *The perennial philosophy*. New York: Harper Perennial. (Original work published 1945)

Lent, J. (2021). *The web of meaning: Integrating science and traditional wisdom to find our place in the universe*. Gabriola Island, Canada: New Society Publishers.

Machin, D., & Mayr, A. (2012). *How to do critical discourse analysis*. London: Sage.

Macy, J. (1991). *Mutual causality in Buddhism and general systems theory: The dharma of natural systems*. New York: State University of New York Press.

Macy, J. (2021). *World as lover, world as self: Courage for global justice and ecological renewal*. Berkeley: Parallax Press.

Macy, J., & Johnstone, C. (2012). *Active hope: How we face the mess we're in without going crazy*. Novato, CA: New World Library.

McQuail, D. (2010). *McQuail's mass communication theory*. London: Sage.

Morrison, D. (2007). Introduction to chapter 7. In *the Bhagavad Gita* (E. Easwaran, Trans., pp. 147–151). Tomales, CA: Nilgiri Press.

Naess, A. (2016). *Ecology of wisdom*. London: Penguin.

Olausson, U. (2005). *Medborgarskap och globalisering: Den diskursiva konstruktionen av politisk identitet* [Citizenship and Globalization: The Discursive Construction of Political Identity]. (Doctoral dissertation, Örebro universitet). Örebro Studies in Media and Communication 3.

Olausson, U. (2018). "Stop blaming the cows!": How livestock production is legitimized in everyday discourse on Facebook. *Environmental Communication, 12*(1), 28-43. https://doi.org/10.1080/17524032.2017.1406385

Olausson, U. (2019). Meat as a matter of fact(s): The role of science in everyday representations of livestock production on social media. *JCOM, 18*(6), A01. https://doi.org/10.22323/2.18060201

Pariser, E. (2011). *The filter bubble: What the Internet is hiding from you*. London: Penguin Group.

Saussure, F. (1959). *Course in general linguistics*. New York: McGraw-Hill.

Spira, R. (2017). *The nature of consciousness: Essays on the unity of mind and matter*. Oxford: Sahaja Publications.

Tolle, E. (2011). *The power of now: A guide to spiritual enlightenment*. London: Hodder & Stoughton.

Wilkinson, R. (1997). Introduction. In *The Tao Te Ching* (A. Waley, Trans. with notes). Hertfordshire: Wordsworth Editions Limited.

Yusuf, N., Al-Banawi, N., & Al-Imam, H. A. R. (2014). The social media as echo chamber: The digital impact. *Journal of Business & Economics Research (JBER), 12*(1), 1–10. https://doi.org/10.19030/jber.v12i1.8369

# 1

# Presence

> I am not absentminded. It is the presence of mind that makes me unaware of everything else.[3]

For communication to function as a tool for stimulating trust, presence is required, which entails full attention to the Now. As the quote above indicates, it is the presence of the thinking mind that makes us absent in life rather than the other way around. When we are completely occupied with our own thoughts, it is impossible to stay aware of the present moment and of what is being communicated here and now. Hence, a prerequisite for trust-building communication is that we are willing and prepared to completely immerse ourselves in the communicative event precisely at the point of its location and in acceptance of its development. It is only in the present moment that we can perceive a relationship as it really is—free from separation, free from past and future, and without the need for manipulative words and actions to obtain certain benefits or affirmation for our constantly deprived egos.

---

3  Quote commonly attributed to G. K. Chesterton.

## The Ego and the Self

The ego is a recurrent concept in this book and deserves some further elaboration. The previous chapter established it as the most rudimentary experience of an "I" that is separated from the rest of creation. We experience the ego as the "voice" speaking in our heads, often both loudly and insistently, and we interpret it as our "person," constituted by particular personality traits. We tend to identify with it, assuming that this is who we are.

But who is it then that observes the ego-mind—the voice in the head—and quite often feels exhausted by its almost obsessive activity? Who is it that performs this metacognitive work—thinking about (or rather observing) the thoughts? Are there two of us in every person, one observer and one observed (cf. Tolle, 2011)? In Hindu philosophy the answer is no, there is no duality whatsoever in who we are. The ego, the observed "person," is *not* us—it is only a fluctuating cluster of thoughts, stories, and convictions about ourselves, and as such it has no reality. The ego is the *Ahamkara,* that is, the not-self. In the observing dimension, however, is where we approach the true Self—unmoving, unborn awareness in which the ego's activities as well as other internal and external objects, including emotions and physical sensations, appear and disappear. The true Self is the *Atman,* the individualized form of the divine, eternal, and infinite essence shared by all beings. In Buddhist terminology this would (roughly) translate to the *Buddha nature* in every individual, and in Christian language to *Christ consciousness.* This dimension is what, for example, yoga and meditation practices ultimately aim to connect with, when delving deeply into the present moment. The very word "yoga" literally means "to unite," and when tuning into our innermost being, the one Self, we unite with the shared essence of all beings. This can only be accomplished in the stillness of the Now.

## Communication Without Goal

Today, goal orientation is a given virtue that we are supposed to apply in well-neigh all contexts. Without targets and objectives, we will not succeed in life, we are told. But when we immerse in and wholly give ourselves to the communicative situation, we also let go of all preconceptions about what it should result in. What we are looking for is a communication that is light, adaptive, and aligned with the natural flow of life (Adyashanti, 2013).

Relationships usually involve wanting something from the other person, even if we may not always be willing to acknowledge this. What we want can be subtle or not so subtle and especially in close relationships we often, more or less consciously, seek to become complete through the other person. The experience of separation and the illusive feelings of lacking and wanting permeate our life situations: "I'm not happy, I want something else in my life!" In the other person, then, we see an opportunity to patch up ourselves and, as a bonus, to contribute to making the other person complete. "You make me whole!" is an established and seldom questioned expression, when describing a well-functioning romantic relationship.

The problem, however, is, first of all, that the experience of lacking something is a thought construction and not the truth about who we are. Obviously, in an indivisible whole, all beings are already complete. Second, and perhaps even more relevant in this context, the futile attempts to become complete through another human being will sooner or later turn in the opposite direction, and the enchanting relationship is replaced by something much less attractive, perhaps bitterness or toxic silence. And last but not least, when we communicate with the goal that the relationship should fill the deep hole of our perceived lacking, we deprive ourselves of the present moment. We always lose touch with the Now and its unpredictable potential when we communicate with the purpose that the relationship should give us something, if only the short-term benefit and satisfaction of being right.[4]

Being present in communication simply means that we leave goals and results behind and instead allow ourselves to flow with the process, no matter if it is going in the right or wrong direction as we (or rather our egos) perceive it. This is about letting go of control of the communicative situation and not allowing the conditioned thought and emotional patterns in terms of ingrained values and judgments to take charge. We let go of all desires that what is happening in the communicative present should give us such and such personal benefit. If we lose sight of the present moment because we envisage ourselves already at the anticipated endpoint, stress and friction arise within. This prevents our communication from paving the way to the place where we and the other person discover our common point of departure; the place where we both are complete, without inadequacies and needs that someone else is expected to take care of and satisfy. So,

---

4 Because many of us regard communication as a tool precisely to convince others that we are right, I will return to this imagined need in chapter 5.

consciously focus your attention only on what is happening at this very moment and trust that what is taking place here and now is precisely what is needed.

## The Metacommunication Inside our Heads

Being present in communication without letting the constant, almost obsessive stream of thoughts interfere, is one of the biggest challenges we face in this communicative transformation process. We have built a society and a life where the present hardly is attributed any value except as a temporal hub for what has been or what is to come. And consequently, when we communicate with others, the voice in our heads—the one we never get rid of even though we may often want to—is actively participating, analyzing what has happened or will happen in the interaction: "What did he think of me when I said that?" "She doesn't listen to a word I say!" "How dismissive they seem!" In this way, the compulsive thoughts keep running in a never-ending stream of analyses and judgments about what is being communicated. And as if this is not enough, the voice inside our head often uses the other person's speaking time to figure out what we ourselves should say when it is our turn to speak.

> If we observe, what we often see when two or more people are communicating with one another is that the one who is not speaking is simply waiting for a gap in the conversation so they can once again assert what they think. (Adyashanti, 2013, p. 150)

When we are not present in communication but preoccupied with thoughts *about* the communicative situation (a kind of metacommunication inside our heads), we often experience a variety of feelings of different intensity: anger, nervousness, anxiety, or some other type of tension. It is not unusual that we experience various more or less subtle threats against our own person, and the ego's voice—hard and competitive or hurt and defensive—makes itself heard. But all analyses, judgments, and tensed feelings that they trigger, originate from experiences in the past, which are reproduced when we allow them to control our communication. We simply permit the present communication to be defined by yesterday's, which no longer exists other than as thought forms. All in all, this drains us of energy and adds fuel to the destructive experience of separation.

Thus, the basic premise for trust-promoting communication is that we are capable of moving beyond the conventional ways of communicating, that is, where what is being communicated (or not communicated) is governed by the

ego-mind with its endless stream of thoughts, desires, judgments and analyses, and instead allow a much greater part of what we actually *are*–beyond the chattering voice of the ego–to shine through and manifest communicatively. And we can only access this in full presence. The present is the only thing we can ever experience because it is the only thing that exists, but many of us have lived most of our lives separated from it, fettered in repetitive thoughts about past or future. Therefore, most people need to practice their ability to be and remain in conscious presence.

## The Wisdom Within

To be able to experience the profound intertwining with others, we need to first become entwined with ourselves, with the "quiet center" within, or slightly reformulated, with the true Self, the one that we really are.

Much has been written about techniques for how to be present (e.g., Thich Nhat Hanh, 2008), so I need not occupy too much space dealing with this topic here. Nonetheless, I want to convey one particular way of practicing presence, which I myself have found very useful. This involves a practice in two steps: the first stimulates "outer" presence, where we focus on the objects of sense perception, and the second aims for "inner" presence where we turn our full attention inwards, and simply become aware of being aware.[5] Both steps are carried by the conscious breath, which serves as the anchor for attention when entering the center of silence.

In the first "outer" step, you immerse yourself in the sensory impressions: the sounds, the smells, the visual impressions, the sensations against your skin, the taste on your tongue. Just stop, come into contact with your five senses, and try to distinguish nuances, differences and similarities, for example in the sounds that come to your ears. Refrain, however, from evaluating or judging the impressions as pleasant–unpleasant, good–bad, beautiful–ugly and so on to avoid getting caught in the dualistic thought patterns that form the very basis for the experience of separation. Also avoid, as much as possible, to conceptualize and label the sensory impressions, such as "the smell of roses," or "the taste of salt." Remain instead in an ever-deepening, wordless experience of what is conveyed by your senses, and evoke the overwhelming sensation of experiencing this for the very

---

5 Obviously, the distinction between "inner" and "outer" is also an illusion and a product of the world of opposites. I use it here for pedagogical reasons.

first time. Let yourself be filled by wonder, like a child, who for the first time sees, hears, and smells the sea, and then allow yourself to relax and simply merge and blend with all impressions. In this way, you gradually sink into that within you that experiences the objects, instead of centering attention on the objects as such. The objects will change but the awareness that experiences them is unmovable.

Thus, in the second step of the presence practice, you turn to your inner or deeper self—awareness—within which the objects, including thoughts, feelings, and communication, take form. Tolle (2011) pedagogically calls this the inner energy field, which you, with some practice, can experience as a buzzing, vibrating or pulsating sensation in the body. When you anchor yourself in this inner presence (or aware awareness) in a communicative situation, you prevent yourself from directing all your attention outwards, throwing it into the communicative interaction (Tolle, 2011). In the words of Adyashanti (2013, p. 119), "you realize yourself to be a deep well of awareness—an inner expanse that's always there. You just have to open to it." Here, in your own quiet center, where you effortlessly and without expectations simply rest in "being," you can observe and actually detach yourself from the thoughts and feelings that are triggered by what is being communicated, instead of instinctively reacting with words.

It is true that we often feel an urge to talk or sulk when negative thoughts and feelings such as anger, pain and uncertainty arise. But when automatic reactions are allowed to control communication, it most likely fails because such reactions tend to trigger similar reactive responses from others. When we, instead of identifying with these thought patterns and emotional reactions, identify with the energy of our innermost being, we are protected from the toxins spread by large parts of contemporary communication, both in the public sphere and in the private.

When we are not constantly trapped in thoughts and analyses but anchored in being, here and now, the opportunities for listening—today so sadly undervalued but absolutely crucial—increase. And by listening, I am not only or even primarily referring to the activity of ears and mind, but to all the compassion we get access to when anchored in the present moment, where we find liberation from the obsessive, labeling, and evaluating ego-mind. When we detach our attention from the world of opposites, a compassionate spontaneity arises that does not originate from the ego's reactions, but springs from an experience of wholeness and togetherness that is saturated with trust. From this place of vast inner space, we can actually sense that the boundaries, the separation, toward the experienced Now of other people start to blur. In Taoist philosophy, the experience of separation is explained by the departure from *Tao*, the Way, and when we align

with the natural flow of life or, in Taoist terminology, with the Ultimate Reality, separation and divergence dissolve.

Through the presence in and the expansion of our own inner space, we gain access to a wisdom that far exceeds that of the mind. Einhorn (2009) talks in his book *Ways to Wisdom*[6] about an intuitive wisdom, which comes with our ability to be present and still; to only watch and listen without evaluating, judging, analyzing, or labeling. A moment of meditation—in close contact with the breath and the stillness within—maybe 10 minutes in the morning before we take on the world, might constitute the difference between a day of turbulence in communication, thought, and emotion and a day of peace of mind, trust, and harmonious communication. Meditation is not just a moment of temporary relaxation but an entrance to a deeper dimension, with which we remain in contact also in the turmoil or tediousness of everyday life.

> To preserve the silence within—amid all the noise. To remain open and quiet, a moist humus in the fertile darkness where the rain falls and the grain ripens—no matter how many tramp across the parade ground in whirling dust under an arid sky. (Hammarskjöld, 1964, p. 70)

Communication that creates genuine understanding and the experience of wholeness, and so has the potential to transcend the boundary between "you" and "me," is just as much about silence and listening in complete presence, as it is about words. We will delve deeper into this in the next chapter.

## References

Adyashanti. (2013). *Falling into grace: Insights on the end of suffering*. Boulder: Sounds True Inc.
Einhorn, S. (2009). *Vägar till Visdom* [*Ways to Wisdom*]. Stockholm: Månpocket.
Hammarskjöld, D. (1964). *Markings* (L. Sjöberg & W. H. Auden, Trans.). New York: Knopf.
Thich Naht Hahn. (2008). *Miracles of mindfulness*. London: Ebury Press.
Tolle, E. (2011). *The power of now: A guide to spiritual enlightenment*. London: Hodder & Stoughton.

---

6 In Swedish: *Vägar till visdom*.

# 2

# Silence

Speak only if it improves on the silence.[7]

Undoubtedly, in contemporary competitive and performance-oriented society, the extroverted has taken precedence over the introverted, and speech has thus been prioritized over silence. But we need to re-evaluate this if we want to stimulate trust through communication. Maybe the saying "silence is golden" is more constructive than generally acknowledged, because communication can do extensive harm, and I am not only referring to the spoken or written word but also to non-verbal forms of symbolic action. One careless word or other sign, which we may forget the moment it is articulated or formed, has the power to remain in another person's memory for an entire lifetime. What has once been communicated can never be undone and the person we have targeted, just like ourselves, must then live with what has occurred. If we cannot answer "yes" to the following three questions, which are commonly attributed to the Sufi mystic Rumi, it may be wise to remain silent:

Is it true?
Is it necessary?
Is it kind?

---

7  Quote commonly attributed to Mahatma Gandhi.

## Deep Listening

At the same time, most of us have experienced that silence too can be very destructive, toxic and full of accusations. In this capacity, it can be used as a weapon to get what we want from another person—for example, that they should take the blame for our disagreement: "She ought to realize what she's done to me!" "He mustn't think that I've forgotten how badly he treated me!" In addition, quite a few of us, perhaps as early as in childhood, have been silenced by various self-designated authorities—parents, teachers, other adults, or older children, who have deemed themselves superior to us—and have therefore lost faith in our rights and in our ability to make our voices heard. If this is the case, perhaps we have to boost our confidence in expressing ourselves before we can really engage in what the Zen-Buddhist monk Thich Nhat Hanh (2013) labels "deep listening."

Thich Nhat Hanh describes deep listening as being grounded in complete presence and the absence of thoughts, where we are in sole contact with the breath and with the inner energy field of the true Self. The act of deep listening then becomes a means of *seeing*—not with the eyes but with the ears and actually with the entire body—and in this way experiencing the energy of the other person's communication. When we sense the vibrations of this energy, not only do we understand the words that are articulated but also what is behind them. And what lies behind the words are *always* either love or a cry for love! When we listen in this manner, compassion for the other person arises, and in situations where we would otherwise have reacted with anger or feeling hurt or provoked, we can instead maintain peace of mind. Through deep listening it is even possible to help our fellow human beings to reduce their suffering, which Thich Nhat Hanh believes is the ultimate goal of communication. It is precisely from the peaceful and compassionate state of mind that we can practice what he calls "loving speech," which reflects a genuine intention of caring. It is only when the words spring from the pure heart, that is, from our own center of stillness, which always exists but can only be accessed when we are fully present, that they carry power and beauty as well as joy and compassion.

Most of us are afraid of silence and fill the interaction with a massive stream of unconscious talk. But if we instead consciously create intervals of silence in communication, we will soon realize that we do not have to say anything at all to discover the connection to the other person. Arguably, spoken words reduce reality to something that can be expressed with a very limited number of sound formations through vocal cords and mouth movements (Tolle, 2011), and they are completely dependent on culturally and individually conditioned meanings that we have ascribed to reality. Instead of relying on these crude instruments of communication, we find the

connection through the heart rather than through words. This does not refer to the emotional heart but to the boundless heart with which we come into contact in the expanse of our deep Self. In the intervals between thoughts, where silence, emptiness and space prevail, the interconnection with the timeless and infinite Now takes place. In this place where seemingly separate selves *commune*, words become redundant because communication is perfect without them.

> … looking deep within the mind, in the very most interior part of the self, when the mind becomes very, very quiet, and one listens very carefully, in the infinite Silence, the soul begins to whisper, and its feather-soft voice takes one far beyond what the mind could ever imagine … In its gentle whisperings, there are the faintest hints of infinite love, glimmers of a life that time forgot, flashes of a bliss that must not be mentioned … where the mysteries of eternity breathe life into mortal time, where suffering and pain have forgotten how to pronounce their own names …. (Wilber, 2000, p. 106)

So, just stop and wait, give the other person space, do not react to everything, be silent, and listen with your whole body; listen—not with a judgmental intention—but with the purpose of understanding whether what is being communicated is love or a cry for love. Is there something your fellow human being feels the need of but is not getting? If so, can you confirm that you understand what this something might be (which does not mean that you have to agree or provide it)? Devote yourself to the communicative situation—dwell in it—and allow it to take time. Do not start giving advice, comforting, explaining or talking about yourself and how you have been affected by or handled similar situations. Do not let yourself be distracted by your own thoughts and judgments but equip yourself with patience. Allow communicative devotion to gradually blur the seeming boundaries between the two of you and make room for the common—the *communion*—to emerge.

# References

Thich Naht Hahn. (2013). *The art of communicating*. New York: HarperOne.
Tolle, E. (2011). *The power of now: A guide to spiritual enlightenment*. London: Hodder & Stoughton.
Wilber, K. (2000). *Integral psychology: Consciousness, spirit, psychology, therapy*. Boston & London: Shambala Publications.

# 3

# Compassion

> If you want others to be happy, practice compassion. If you want to be happy, practice compassion.[8]

Basically, compassion is about the "golden rule," which unites all major wisdom traditions. In Christian teaching, for example, it is expressed in the statement "… whatever you wish that others would do to you, do also to them …" (Matt. 7:12, ESV), and in Muslim teaching in the declaration "… love for your brother what you love for yourself" (Hadith 13). Obviously, this golden rule also applies to how we communicate with each other.

Compassion is, however, often linked to a presumption that will be examined here, namely that it is always directed outwards—toward another person (or persons) who in some way is suffering and is in need of our compassionate attention. But compassion always starts with ourselves! The Buddha allegedly said that compassion is otherwise incomplete and, obviously, we cannot give to others something that we ourselves do not own. If we do not accept ourselves with our imagined flaws and shortcomings, it becomes extremely difficult to compassionately embrace similar flaws and shortcomings in other people. If, on the other hand, we have genuine compassion for ourselves, the step to opening up also for compassion for others has basically already been taken.

---

8 Quote commonly attributed to Dalai Lama.

## The Illusion of Perfection

As Thich Nhat Hanh (2013) points out, compassion for yourself is not just about communicating with and listening compassionately to yourself, but even to learn to *love* your negative and attacking thoughts. This means that we embrace our feelings of discomfort that are the result of these thoughts (or that may have already been there and triggered the negative thoughts), as if we had chosen them ourselves. We face ourselves, acknowledge our own suffering and just stay with what hurts, without trying to escape or pushing away the pain— without making a problem of it. Instead, we simply embrace everything that appears in our field of attention.

> Each time you meet an old emotional pattern with presence, your awakening to truth can deepen. There's less identification with the self in the story and more ability to rest in the awareness that is witnessing what's happening. You become more able to abide in compassion, to remember and trust your true home. Rather than cycling repetitively through old conditioning, you are actually spiraling toward freedom. (Brach, 2013, p. 73)

Are the thoughts of a self-accusing, blaming, attacking nature? Acknowledge them, but do not start "fixing," managing or controlling them. Just accept the thoughts and feelings as they come. Whatever they are and whatever they look like, place the light of consciousness on any experience and stay with it. Be with it. Do not *think* about the experience—refrain from labeling it—but direct all your conscious attention to it. Do not strive to eliminate the discomfort and create a different state of mind—to have peace, to be happy, to feel joy—because it is precisely this struggle to escape from what *is*, that stands between you and the desired states. So, just rest and let yourself be carried through the pain.

> Resting through pain, sorrow and despair is so liberating because it creates a space within us, where we are allowed to be in the moment. Not everything needs to be fixed or arranged, cleaned or decluttered. Let it be as it is, let it take the time it needs, let it hurt as much as it really hurts. Because in resting, there is also the awareness that everything will pass. (Nyholm, 2011, p. 24, author's translation)

Compassion for oneself is thus accomplished by stopping and letting go of the pursuit of perfection. Compassion is to face what is difficult and seemingly flawed with an open and forgiving embrace. This appreciation of what is damaged and deficient has been illustratively described in the Japanese aesthetic *Wabi Sabi*,

which is often called the "religion of beauty" (e.g., Nyholm, 2011). *Wabi Sabi* honors the imperfect as part of the ever-changing and perishable character of this world, and it is considered beautiful and attractive due to its authenticity.

In the same way, we must compassionately face and acknowledge the dark and far from perfect sides of the ego, both in ourselves and in others, and view communication—which 9 times out of 10 comes from the ego—in a compassionate way. We have to accept that we do not get our message across in a perfect way, that we will never be fully understood by other people or fully understand them through our established ways of communicating. Meaning-making is far too complex for communication to work as a disturbance-free transfer of information, and most of the time we are unable to neutralize the quickly arising and almost automatic feelings of discomfort. In short, communication frequently triggers unpleasant and conflictual inner states.

Nonetheless, stay put, do not attempt to escape but simply rest in presence and stillness throughout the situation. Note and acknowledge the feelings of discomfort but try not to act communicatively on them. Remember that no matter how bad things seem right now, this—like everything else—will pass. And, as Gangaji (2020) so aptly puts it: "there is actually plenty of room for experiences of imperfection in perfection." The fact that we experience inadequacy and flaws in our own and others' communication does not affect the perfection of the indivisible web of life that we all are part of. Moreover, when we use communication in order to restore trust between people, the ultimate purpose is not to make ourselves perfectly understood, or to make meanings common, in every situation. The concrete information in the communicative situation is subordinate to its trust-promoting—communing—potential and when that potential is realized, understanding and compassion also arise on a completely new and deeper level than the purely literal one.

The prerequisite for genuine, trust-enhancing compassion for others is thus, first and foremost, that we establish compassion for ourselves, because when we have compassion and tolerance for our own perceived imperfections, we lay the foundation for the ability to empathize with and tolerate the imperfections of others. When we release the identification with the person we think we are, that is, the ego, and allow attention to sink inwards and become completely still—experiencing the silence between the words, feeling the breath—we know the essence of ourselves. When we are immersed in our innermost being, we can distance ourselves from, observe, empathize with, and forgive that which belongs to our outermost being—the ego. And it is also from this point, the essence of

ourselves, we can feel with the essence of other people; that which lies beyond their personalities and often ego-driven communication.

Compassion for ourselves and others is ultimately not about empathizing with the ego's manipulative maneuvers, but about looking beyond them, forgiving them as illusions that obscure what is eternally true about us, embracing our common essence instead of focusing on that which seems to separate. Admittedly, this is easier for some individuals and groups than for others depending on socio-economic status and context, but this must be the goal. Effortless, spontaneous compassion exists only in the pure space of "being," and when many people immerse in this rest together, compassion expands into a shared and very quiet remembrance of who we really *are*—intertwined into an indivisible whole and liberated from fear and all its expressions. Every trace of separation disappears, and in this experience of absolute trust even compassion becomes redundant.

## The Deceptive Victim

In everyday speech, it is quite common not to distinguish between compassion and pity. Both concepts may represent the ability to experience another person's suffering and thus the ability to put oneself in "another person's shoes." However, if we want communication to contribute to building trust, we only practice compassion. Even if the heart writhers with pain when we witness the suffering of other beings (which is really just a sign that we experience the union of all life), we do not make active attempts to take over this suffering. When we practice compassion for another person, we communicate with the goal of reducing that person's suffering through deep listening in intense presence, where we confirm that we understand that the person is suffering—crying out for love—and perhaps even acknowledge the unsatisfied needs behind the suffering (Rosenberg, 2003). But we avoid pity in terms of co-suffering, that is, going into and reproducing the pain ourselves (cf. co-addiction).

Compassion is, as Ram Dass (2011, p. 215) reminds us in the book *Be Love Now*, to experience the other's pain as our own *but* with the wisdom that the knowledge and experience of oneness brings with it. This is not a minor challenge for the individual, who has developed the *ecological self*, which is eco-philosopher Arne Naess's (2016) label for people who genuinely experience all life as their own. It is extremely painful to live in the midst of the unfathomable suffering of the world as it appears to us, but the fact is that we need to stay wide open to compassionately embrace it.

What we should be vigilant about, both when it comes to compassion for oneself and compassion for others, is the prevalence of a victim role that effectively transforms compassion into self-pity or pity for others (Boltanski, 1999). In most situations associated with suffering, it appears as if there is one or several circumstances that have caused the suffering and that are attributed guilt (e.g., people, illnesses, situations), that is, they are used as scapegoats. Consequently, we can also identify one or more victims, who suffer from the effects of these circumstances. However, in order to set the stage for trust to grow, we consistently avoid confirming someone as a victim by becoming co-sufferers, even if the person *is* a victim, objectively speaking.

Undoubtedly, there are individuals and groups who must be recognized as victims of structural forces such as discrimination based on, for example, ethnicity, gender or sexual orientation. Globally, poverty, famine and armed conflicts have also created unimaginable suffering for completely innocent people. But, as media research shows, we should avoid attributing them the role of victim, whatever their situation, because at the same time as they are communicated as victims, they are also portrayed as voiceless, unable to handle their own circumstances and without the ability to represent themselves (Shaw, 1996). Research have verified that being a passive and silent victim is a prerequisite for being regarded and portrayed as a "worthy" one. At the very moment the victim becomes active and somehow confronts their situation, there always seems to be something to accuse them of (Chomsky & Herman, 1988).

The victim role is, however, fairly common even if we are not exposed to either discrimination or catastrophic situations. It can be actualized for other reasons because of circumstances we think we cannot control—illness, unemployment, nasty people—anything that we think has "happened" to us. However, the victim risks becoming one of the ego's most powerful roles through which, as Gibson (2017) suggests, it not only reproduces suffering but also markedly intensifies it.

If we have ascribed ourselves a victim role, which has been confirmed and reinforced by people who pity us, it is also highly probable that we are communicatively manipulating other people when playing this role, intentionally or unintentionally. Because we are victims of the circumstances, other people must give us special attention, be considerate, and, overall, give us special treatment. In short, in the victim role, we present ourselves as special. But in order for us to (re)establish the necessary trust in each other and in our existence in the world, relationships must be equal (cf. Buber, 2013), and such "specialness" renders equality impossible. Thus, compassion for oneself means "offering yourself the

kindness and care you'd give to a close friend" (Lent, 2021, p. 75) but getting rid of self-pity.

Liberation from suffering can only occur when we look beyond all illusory roles—the images of ourselves that we communicate—to our indestructible and untainted essence. In this place, true healing and release from suffering can flourish, because we get access to a much greater part of our true potential and to an enormous source of joy. Here, we can replace the victim's focus on *receiving* (consideration, pity, etc.) by extending compassion and *giving* to others (cf. Gibson, 2017), which in the end is the only sustainable way to actually receive what we need. Thoughts possess an enormous creative power and when we feed the thoughts about ourselves as victims of the circumstances and our life situation—when this becomes our cry for love—suffering also becomes the reality we will experience. Do not build your house on such an unstable foundation, and do not confirm any such constructions among your fellow human beings.

## Compassion Without Boundaries

> A human being is a part of the whole called by us universe, a part limited in time and space. He [sic] experiences himself, his thoughts and feeling as something separated from the rest, a kind of optical delusion of his consciousness. This delusion is a kind of prison for us, restricting us to our personal desires and to affection for a few persons nearest to us. Our task must be to free ourselves from this prison by widening our circle of compassion to embrace all living creatures and the whole of nature in its beauty.⁹

Compassion has no boundaries. This means that it is not limited to ourselves and other human beings. Communication in the form of communion, where we in reciprocity (re)discover the existing connections between us, is as accessible between animals and humans as it is between humans. I have experienced this firsthand during my years as a riding instructor. When the rider lets go of their pressure to perform; when no anxious thoughts or feelings disrupt communication and create tensions and conflicts, when complete trust prevails, horse and rider merge into their natural state—they become one. No complicated techniques are required for the horse and rider to understand each other, because the

---

9 Quote commonly attributed to Albert Einstein.

boundary between them—the optical illusion, according to the opening quote—is dissolved. All that exists is a single extended I.

Emelie Cajsdotter, who communicates with animals in general and horses in particular, illustratively describes this state of oneness in SVT's[10] documentary series *The Herd*[11] (Mannheimer & Åkerlind, 2019, author's translation), which shows how horses can teach people how to move on to the next developmental stage. She explains her communication with horses like this:

> You have to disregard the idea of what talking would be. I believe that spoken language arises because there's a distance [a separation, author's remark]. And because there's a distance and you can't feel what's within me right now, I must try to explain it to you. Then, I have to first formulate it to myself and then I have to pass that on to you, and you'll understand it based on what you yourself have been through. And somewhere in that lengthy process, we'll lose track of what it is we're trying to say to each other. But if I imagine that I'm in the center of my own self, and kind of expand it, so that I move away from my own imagined identity, and the self becomes empty ... I still know who *I* am, the self can only be infinite really. Then, there's room for the other. And then, for a moment, I can experience how the other is experiencing their situation, right now.

Maybe it sounds strange that the boundary between human and animal is illusory and that it relatively easily can be dissolved? Perhaps it seems more reasonable to reserve compassion only for interpersonal relationships? In that case, this is a good example of how profoundly entangled we are in duality, where the human opposite is spontaneously understood as the animal. Our pejorative view of the animal—the ego's desire to feel superior by contrasting itself with something "worse" or "subordinate"—is clearly noticeable in unconscious language. For instance, we may say that someone is displaying "animal-like behavior" when we want to highlight how badly they are behaving.

In addition, the idea that animals are subordinate to us and that their function is to serve human purposes is naturalized and self-evident to many of us. This applies not least to the role of animals as human food. Joy (2011) proposes that a largely taken-for-granted and deeply ingrained thought system, which she calls *carnism*, shapes our notions of the meat, eggs, and dairy products we consume. This thought system means that we without the slightest questioning or further reflection love certain animals—in Western culture, for instance, dogs—whereas

---

10  Public service broadcaster Swedish Television.
11  *Flocken* in Swedish.

we contentedly consume others, for instance, pigs and cows, without really knowing or being able to argue why this is. Without hesitation, we even consume the animals' children: chickens, calves, and lambs, the latter with an extra amount of delight. These children have simply been defined, naturalized, and communicated as delicacies for human beings to enjoy, not as individuals with the right to their own lives (e.g., Kemmerer, 2014). We have also convinced ourselves that animals are machines, and do not feel pain as we do; that "it's okay to throw a lobster into a pot of boiling water because, after all, it's just a lobster" (Lent, 2021, p. 24).

Here we return to the need to "denaturalize" communication, which was addressed in the introductory chapter, and remind ourselves of our agency; that which enables us to influence the language structures that limit and encapsulate our thinking and action in inert but definitely not static norms. We thus have the opportunity to reveal and become aware of the naturalized and separating human-animal dualism and all the thoughts and behaviors connected to our diet we have been taught as children. Most of us have learned at a very early age that (some) animals are natural and necessary food for humans and because of this we do not question our eating habits unless we begin to critically reflect on what seems precisely "natural" (Olausson, 2018). We need to acknowledge that the meaning of concepts such as "natural" is not given or universal, but changes over time and differs between geographical, historical, and cultural contexts.

Only a few of the many self-professed animal lovers, who share pictures of cute animals on Facebook and who see themselves as advocates of animals and nature, actually see through the taken-for-granted thought system that constitutes *carnism*—this belief system (*shraddha*) that makes it seem self-evident that (some) animals' only purpose in life is to be or produce food for humans. But, as Ram Dass (2011) wisely reminds us, in the all-inclusive compassion we cannot omit the animals, the trees, the planet or the galaxies. Everything is One—one single entwined energy, where complete equality prevails. This means that *no one* is superior or more significant than anyone else. *Ahimsa*, which is one of the five main ethical principles in yogic philosophy and means non-violence, is not limited to the human race but implies a universal compassion for all living beings.

The author Leo Tolstoy (2018) even went so far as to claim that as long as there are slaughterhouses, there will also be battlefields. The statement might be considered overdramatic in today's context of animal welfare, but the fact is that 74 billion animals are killed for food worldwide, most of them "enduring tortured, confined, unnaturally brief lives of appalling suffering" (Lent, 2021, p. 250). Tolstoy also effectively draws attention to the fact that cruelty is structurally

conditioned. It is not limited to any particular area of society but is embedded in many spheres of what we perceive as reality. The fact that cruelty transcends many different domains of society, contributes to it being legitimized as "natural" in our thinking and communication. Therefore, in order to reveal and denaturalize the structural cruelty and develop genuine compassion, we need to think and communicate outside the framework we were socialized within and include the beings that we have chosen to label "animals." The greatest challenge to such an inclusion is probably the cognitive dissonance that results from the significant clash between, on the one hand, the recognition of the naturalized structures of thinking and communication that legitimize cruelty to animals, and, on the other hand, individuals' (laymen and scholars alike) established and naturalized eating habits (Freeman & Zimmerman, 2022).

Once we have begun to question the human-animal dualism, the obvious next step is to start reflecting on the related nature-culture dualism, which has resulted in the separation of humans from nature, and that humans have attributed to themselves the role of nature's superior. In the dualistic thought system, nature has no intrinsic value; it is more or less taken for granted that its raison d'être first and foremost lies its function as a "resource" for humans to manage, dispose of or exploit at will (Cronon, 1996).

But non-human lifeforms have their own reasons for existing! Lent (2021) refers to biologists' discovery that plants have their own complex system of reactions and senses similar to and even beyond ours. Trees communicate with each other in the most fascinating ways through the root system and in symbiosis with the fungi mycelium, and they live in what we would label communities. The fact that we cannot perceive this is due to our lack of understanding and perhaps also interest in the subtle details of non-human lifeforms, and this has led us to believe in—naturalize—human uniqueness and superiority in every respect. In mainstream discourse, the continuous denial of the profound similarities between human and non-human lifeforms is evident, and as a kind of ideological fundamentalism it has been labeled "anthropodenial" (Lent, 2021, p. 51).

Instead of continuing to reproduce these separating and—as it has turned out with utmost clarity—completely unsustainable structures, we can choose other thoughts and other ways of expressing ourselves to expand our compassion to include a larger sphere of life. We constitute the seamless whole together with so many other lifeforms than those in human form—we live in a *more-than-human world* (Abram, 1997; Naess, 2016)–and this will be further elaborated on in the concluding chapter.

When we communicate compassion across seemingly obvious boundaries such as that between animal, plant, and human—when we loosen the dualistic thinking and communicating, and, above all, when we *live* this compassion fully—universal trust expands as the experience of boundaries, opposites and separation shrinks.

# References

Abram, D. (1997). *The spell of the sensuous: Perception and language in a more-than-human world*. New York: Vintage Books.

Boltanski, L. (1999). *Distant suffering: Morality, media and politics*. Cambridge: Cambridge University Press.

Brach, T. (2013). *True refuge: Finding peace and freedom in your own awakened heart*. New York: Bantam.

Buber, M. (2013). *I and Thou*. London: Bloomsbury Academic. (Original work published 1937)

Chomsky, N., & Herman, E. S. (1988). *Manufacturing consent*. New York: Pantheon Books.

Cronon, W. (1996). The trouble with wilderness: Or, getting back to the wrong nature. *Environmental History, 1*(1), 7–28.

Freeman, C. P., & Zimmerman, A. (2022, April 19). "Take extinction off your plate": How international environmental campaigns connect food, farming, and fishing to wildlife extinction. *Environmental Communication*. https://doi.org/10.1080/17524032.2022.2060276

Gangaji. (2020, February 5). The habit of suffering. *Gangaji's Blog*. https://gangaji.org/gf-blog-post/the-habit-of-suffering

Gibson, K. (2017). *Från offer till självinsikt: 30 lektioner som förändrar dina tankar om sjukdom [From victimhood to self-insight: 30 Lessons that change your thoughts on sickness]*. Stockholm: Gibson Musik.

Joy, M. (2011). *Why we love dogs, eat pigs, and wear cows: An introduction to carnism*. San Francisco, CA: Conari Press.

Kemmerer, L. (2014). *Eating earth: Environmental ethics & dietary choice*. Oxford: Oxford University Press.

Lent, J. (2021). *The web of meaning: Integrating science and traditional wisdom to find our place in the universe*. Gabriola Island, Canada: New Society Publishers.

Mannheimer, C., & Åkerlind, A.-L. (2019). *Flocken (The Herd)*. SVT Play. Retrieved September 14, 2021, from https://www.svtplay.se/flocken

Naess, A. (2016). *Ecology of wisdom*. London: Penguin.

Nyholm, A. (2011). *Wabi sabi: Tidlös visdom [Wabi Sabi: Timeless wisdom]*. Stockholm: Norstedts.

Olausson, U. (2018). "Stop blaming the cows!": How livestock production is legitimized in everyday discourse on Facebook. *Environmental Communication, 12*(1), 28–43.

Ram Dass (with Rameshwar Das). (2011). *Be love now: The path of the heart*. New York: HarperOne.

Rosenberg, M. B. (2003). *Nonviolent communication: A language of life*. Encinitas, CA: PuddleDancer Press.

Shaw, M. (1996). *Civil society and media in global crises*. London: Pinter.
Thich Naht Hahn. (2013). *The art of communicating*. New York: HarperOne.
Tolstoy, L. (2018). *The first step: An essay on the morals of diet, to which are added two stories*. Franklin Classics Trade Press. (Original work published 1884)

# 4

# Generosity

> Generosity is the most natural outward expression of an inner attitude of compassion and loving-kindness.[12]

Compassion is, just as the introductory quote claims, intimately associated with generosity. Regrettably, in our materialistic, economy-centered society this particular quality has been banished into obscurity. (Economic) "growth" is the norm and the idea that prosperity can be measured in something as abstract as gross domestic product (GDP) is established and naturalized. These materialistically permeated structures are contagious and saturate also our thinking and language, which in turn contribute to the reproduction and naturalization of these structures—rendering them invisible and protected from critical questioning.

In the "have-society," we thus believe that accumulation of money and property bring happiness and well-being. But the truth is that this materialistic lifestyle takes us further away from what we most wish for, namely peace of mind. As noted by Wilkinson (1997, p. xvi) in the *Tao Te Ching*, "the less people desire, the less they will be unquiet and unhappy." Furthermore, the "have-society" feeds ideals about receiving rather than giving, and once we give, the very act is characterized by the materialist ideology, that is, the idea that generosity is primarily about sharing materially. This view of generosity is, of course, far from unfounded; in order to (re)establish a trusting society, which is based on equality

---

12 Quote commonly attributed to Dalai Lama.

in all respects, it is essential that material abundance is shared with the less affluent. But if we reduce generosity to the material domain only, this easily leads to the notion that we ourselves lose what we give to someone else, which is not true for compassionate generosity.

Neither does materialistic generosity require that we give from the heart (Rosenberg, 2003), but we can dutifully donate money, clothes or things to relevant purposes without being truly motivated or committed. Donating simply makes us feel good. When giving becomes an ego-affirming ritual rather than an expression of genuine compassion, it has lost much of its trust-building power. As emphasized by Easwaran (2007, p. 53) in the *Bhagavad Gita*, "[work] may benefit others, but it will not necessarily benefit the doer. Everything depends on the state of mind." Thus, the dualistic understanding of generosity, that is, that there is a giver who loses something and a receiver who gains something, is a product of the ego's involvement in the act of giving or serving. When it comes to generosity in a nondual perspective, the giver benefits as much as the receiver, and the next section addresses how compassionate generosity in fact results in the dissolution of duality.

## Giving and Receiving

The generosity that is the fruit of genuine compassion reaches far beyond the dutiful giving of material things. The Swedish somewhat old-fashioned word, "giv-mildhet," which is an equivalent of generosity and roughly translates as "give-gentleness," is perhaps the best signifier of what compassionate generosity means. Just as compassion embraces both ourselves and others, the "giving of gentleness" generates the same benefits for the giver as for the receiver. The English word "charity" in its original sense is also suitable in this context. Today it has, as Huxley (2009, p. 82ff) points out, become another word for almsgiving instead of an expression of the highest form of love. In the latter capacity, charity seeks no reward, it is tranquil and humble, and it is in this sense "generosity" should be understood here.

If we accept the ontological premises of the communication ethics suggested here—that we are not independent, separated entities but innumerable, interconnected channels that extend to a single indivisible Self—we realize that all the gentleness and charity we give to others also belong to ourselves. Giving is simply the same as receiving, everything else is a dualistic misunderstanding. So, when we communicate gentleness, practicing charity, this is also what we will perceive

in the world. In light of this, we can perhaps better understand what Jesus meant when he claimed that "it is more blessed to give than to receive" (Acts 20:35, ESV). The statement does not imply that we are better people when we give than when we receive; the point is instead that the act of giving is itself the only way to—the necessary condition for—receiving.

In the previous chapter, the importance of letting compassion begin with ourselves was emphasized, that is, that we are capable of giving gentleness to, embracing and acknowledging all aspects of our own person, even the painful ones and those we would rather hide. This is not a minor thing but actually a prerequisite for us to be able to show generosity and give gentleness to others; they who do not have cannot give, and they who do not give cannot receive. But if we have compassion for ourselves and extend (give) it to others in loving speech and deep listening, we simultaneously include ourselves in the trust-opening communication climate. The gentleness we give does not disappear because we extend it to someone else but grows to become all-encompassing. The perceived separation starts dissolving and it becomes increasingly difficult to distinguish who is the giver and who is the receiver of the extended, expanding compassion. Or, as put by Rosenberg in the book *Nonviolent Communication* (2003, p. 1): "what I want in my life is compassion, a flow between myself and others based on a mutual giving from the heart."

Carlsson (2014) describes this process in terms of extending grace. Grace is constantly available to us, and we can experience it when we are in contact with our innermost essence—the quiet place within, where we effortlessly simply *know* that we do not need to "fix" anything about ourselves; we are already safe, complete and without guilt. And when we communicatively extend this state of grace to others, our own experience keeps intensifying. In other words, the more we allow grace to grow and embrace others, the more the grace that was ours already from the beginning expands and extends to include other (human) beings. From this non-materialistic perspective, Jesus's often misinterpreted statement "For to the one who has, more will be given, and he will have an abundance…" (Matt. 13:12, ESV) appears highly reasonable. Owning and extending compassion and gentleness is thus a prerequisite for trust-building communication because this expansion of generosity blurs the boundary between giver and receiver. In this way, it dissolves duality.

Most ethical-spiritual teachings include the principle that our actions—what we do (and do not do) in this life—have consequences not only for others but also for ourselves. For example, the *Bible* says, "… whatever one sows, that will he also reap" (Gal. 6:7, ESV), and the *Bhagavad Gita* (3:1) describes the positive

repercussions of how we live our lives in terms of *karma yoga*, which means that "through selfless service, you will always be rewarded and find your desires satisfied." Thus, active giving and service completely free from selfish motives and without any expectations of the result are the most effective ways of obtaining what we ourselves need.

Being generous based on ego-induced motives, on the other hand, maintains dualistic thinking, which increases the risk that thoughts of fairness and debts of gratitude take root in thoughts and communication: "I keep giving and giving, but get nothing in return." "I've always been there for you, but you're never there for me." "I've given him so much money, but he only takes it for granted." With selfish motives in giving—even if they seem ever so trivial—we effectively imprison ourselves in the state of separation and in the unsettling lack of trust.

Chapter 1 addressed the importance of allowing ourselves to "float" with the communicative process and to become completely immersed in it instead of struggling to control its results. The intense presence together with deep listening and patience also determine the nature of the act of giving—this is not something we need to constantly think about. On the contrary, compassionate giving requires the absence of automatic analyzes and assessments that govern the direction of the communicative act, and what it is supposed to "give" us in the end. When we give up all desire for personal reward and instead use communication—with or without words—in presence, to extend compassion and gentleness, nothing is lost for ourselves. What we expand, extend and share we unconditionally receive back at some point and in one form or another. In SVT's[13] documentary *The Nun*[14] (Nycander, 2007, author's translation), Marta, who joined the Carmelite Order at the age of 19, puts accurate words on this type of generosity:

> Love has been so much misunderstood. And happiness too. It's believed that it's simply about satisfying your desires. But happiness is really to be able to give [of yourself]—and to receive of course—to be able to live for others. And if everyone did that, the world would be a very different place.

---

13 Public service broadcaster Swedish Television.
14 In Swedish: Nunnan.

## The Old Ladies and the Beggars

Although I stated at the outset of this chapter that material generosity is often ego-based, there is, of course, nothing to stop us from giving also material things "from the heart" and with gentleness. Everything in the world of form is perishable, but compassion is eternal and can be extended infinitely.

To illustrate this, "the old ladies and the beggars" may serve as examples. In recent years there has been a substantial increase in begging in Sweden (at least before the outbreak of the COVID-19 pandemic). The beggars are mostly women from other countries, which has caused a great deal of debate; what is the right behavior in relation to beggars? Should one be "generous" and put a penny in the beggar's paper cup, or does this just feed an oppressive system that consolidates the subordinate positions of these people? Is it not, in fact, a very "banal" kind of goodness that we demonstrate, when handing over our little gift (Heberlein, 2017), that is, an unquestioned and dutiful kindness, which only feeds our egos and provides us with the opportunity to feel righteous about ourselves?

From the nondual perspective, the answer is simply that it is our state of mind when we donate the gift that determines its nature. Are we generous based on the selfish motives of the separated ego, where we give to elevate ourselves in goodness and self-righteousness and to convey such images of ourselves to others? If so, we are the kind of givers that the *Bhagavad Gita* even describes as "demonic" in our self-centeredness. Or does the gift come from the entwined Self, where we communicate gentleness by extending compassion beyond the illusory boundary between you (the giver) and me (the receiver)?

Here the "old ladies" serve as excellent examples of the latter state of mind. On many occasions, I have stopped for a while outside the supermarket in the local community to watch these ladies stop for a moment with the begging woman. The amount they give is small, but the gentleness is great. In this giving there is no sign of dutifulness or ego motives, but the entire communicative act, which takes place mainly without words but with gentle touch and gaze, is rooted in the intuitive recognition that "You are another I."

In this way, when the inherent connection—the communion—between these women is given space to manifest, giving becomes an act of genuine compassion and there is no expectation whatsoever about the result. When generosity is practiced like this, it has nothing to do with the ego-boosting kind of pitiful giving that consolidates structures of superiority and subordination between the women. And no one in this interaction loses anything, because compassion is shared and extended to the benefit of both.

Moreover, this compassionate generosity does not stop with these two trustingly communicating women but creates a ripple effect, magnifying in increasingly wider circles. It becomes a concrete example of Carlsson's (2014, 24 July, author's translation) suggestion that we "by having the courage to be generous and lead a life of compassion [can] become each other's guides and light," as well as an embodiment of the assertion, commonly attributed to Rumi, that "your acts of kindness are iridescent wings of divine love, which linger and continue to uplift others long after your sharing."

The selfless generosity—or the charity—can thus be seen as one of the most important principles for building trust, because it takes us into (and actually requires) presence and stillness. We are in contact with our innermost being to which the ego has no access; the place where its habitual and often aggressive thoughts about justice and gratitude can be viewed from a distance and as something which has nothing to do with who we really are.

## References

Carlsson, O. (2014). *Just idag: 365 tankar för sinnesro* [*Thoughts for the day: 365 Reflections for peace of mind*]. Stockholm: Bonnier Fakta.

Easwaran, E. (2007). Introduction. In *The Bhagavad Gita* (E. Easwaran, Trans., pp. 7–67). Tomales, CA: Nilgiri Press.

Heberlein, A. (2017). *Den banala godheten: Mångkultur, integration och svenska värderingar* [*The banal goodness: Multiculturalism, integration and Swedish values*]. Stockholm: Greycat Publishing.

Huxley, A. (2009). *The perennial philosophy*. New York: Harper Perennial. (Original work published 1945)

Nycander, M. (2007). *Nunnan* [*The Nun*]. SVT Play. (Expired 2 October, 2020, retrieved August 4, 2020).

Wilkinson, R. (1997). Introduction. In *The Tao Te Ching* (pp. vii–xix). Hertfordshire: Wordsworth Editions Limited.

# 5

# Open-Mindedness

Everything we hear is an opinion, not a fact.
Everything we see is a perspective, not the truth.[15]

Communicative compassion and generosity require a humble and open mind that has not been clouded by arrogance and preconceived notions. Without yielding to extreme knowledge relativism of the postmodern kind, it is constructive to acknowledge that what we think we know about other people and about the world around us are merely assumptions and opinions. All knowledge of the world is to varying degrees unstable, fragmentary and reflects what we perceive as reality from often very narrow perspectives. We live with flawed, limited, and distorted perception every day and we believe in the thoughts it gives rise to. However, what we perceive through our senses is strongly colored by the past, both the individual and the collective, which functions as a filter through which we interpret everything that temporarily takes form around us.

Additionally, in today's fragmented mediascape, it is possible to almost completely avoid being exposed to impressions that do not fit with this filter. We can now make an active choice to remain in closed eco-chambers that reproduce our particular worldview and to select websites, social media, pods, and the like that describe the world from the same filtered perspective. In this biased manner, we receive further confirmation that it is precisely our perspectives and thoughts

---

15  Quote commonly attributed to Marcus Aurelius.

that reflect reality. However, in order for communication to promote trust, it is necessary that we humbly recognize our inability to comprehend reality through the limited sensory organs we have at our disposal. Most conflicts—at all levels of society—arise precisely because we all communicate our own or our (imagined) communities' thoughts and perspectives, and because we all believe that these thoughts and perspectives are the only true and accurate representations of reality (Adyashanti, 2013).

This means that we need to take another and critical look at our taken-for-granted conceptions and acknowledge that no two people have the same thoughts about what is true and real. When we communicate unconsciously—on autopilot—the risk is imminent that we constantly find ourselves in situations where we feel that we have to convince the other person that their thoughts are wrong, while at the same time ferociously defending our own ideas (because they are the ones representing reality!). But in order for trust to take root through communication, we need to look beyond our own naturalized thoughts, beliefs, values, and opinions; we have to open ourselves to the possibility that they may not be true—not the thoughts about ourselves and not the thoughts about other people or the world around us. We need also open our minds to the idea that this is not even the most important thing in communication. Perfect coherence of meaning is hardly feasible, and this is not what the communication ethics proposed here seeks to achieve.

## Ascribing Objects Meaning

The sociolinguistic tradition of semiotics studies the ways in which meaning is shaped through language. Early semioticians such as Ferdinand de Saussure and Charles Sanders Peirce realized that the words and the language we use for communication *never* represent the real conditions or an objective world; they are just symbols or "signs" of particular objects, and as such they are incapable of mirroring them.

Saussure (1956), who was a linguist and interested in the relation between signs, distinguished between the *signifier*, such as the written or spoken word, and the *signified*, the mental conception or interpretation of the signifier. For example, when I use the word "tree" (signifier), I may mentally imagine a tall, beautiful oak tree stretching its crown up in the sky (signified), while you, when you hear me say this word, may interpret it in terms of a crooked pine on a beach, tormented by the harsh sea winds. Here, Saussure highlights the simple fact that

it is not at all evident that two people connect a word ("tree" in our example) to the same mental notion. Of course, if we belong to the same culture, subculture, or family, the probability of agreement increases, but even so, one hundred percent coherence cannot be guaranteed. Even if I would specify the tree to the level of species, for example, "oak tree," there exists a variety of mental images of an "oak tree" too. So already at this stage—in the relationship between signifier and signified—we realize that words are empty signs, signifiers or symbols that are ascribed different meanings by different people. Moreover, if objects or actions in a seemingly objective reality are added to this (the real Tree in our example), the construction of meaning certainly does not look any easier. In Peirce's (1992) three-tiered model, he distinguishes between the *sign*, the word "tree," and the *object*, the real Tree that the sign wants to represent. To this, Peirce adds a stage of *interpretation*, both in terms of the object in the world (what a Tree actually is) and the mental conception (the image or knowledge of the "tree" in our heads).

Abram (1997) suggests that language should be regarded as a kind of code that represents different objects but lacks the inherent and direct connection to the very same objects. In contrast to, for example, ancient cave paintings, language does (usually) not seek to mimic the objects it wants to represent but is a more or less arbitrary collection of sounds or visual signs. This is why the making of meaning goes in many different directions, takes very different shapes, and, in fact, very rarely coincide between people.

Thus, semioticians make clear that an object in what we perceive as reality has no meaning until it is attributed such through our mental and linguistic processes. "The world has to be made to mean," as Stuart Hall (1995, p. 355) aptly argues. And this making of meaning varies with geographical, historical, cultural, and individual contexts, something which also applies to our understandings of other people. The next section develops this line of thought further.

## Ascribing People Meaning

In the same way that we, with the help of thoughts and language, provide different objects in the world with meaning, we also attribute different ideas, intentions, and motives to other people. We thus interpret others through our own individual and cultural frameworks of understanding. And just as we realize that the meanings we ascribe to a "tree" vary from individual to individual, we must also recognize that the intentions, thoughts, and feelings that we ascribe to other people are subjective and do not necessarily correspond with reality. In

fact, the characteristics that we attribute our fellow human being rather mirror—ourselves! This means that we simply project our own thoughts, feelings, and intentions onto the other person. "I am not who you think I am. You are who you think I am," as some anonymous person once said. Adyashanti (2013, p. 151, italics in original) suggests that we have much to gain by recognizing the mechanisms of such projection because "when we come to see that words aren't the truth, that what people say about us tells us about *them*, not us, we don't worry so much about what someone might say about us."

Not only is it impossible for us to embrace an objective reality with our thoughts and language; what we think and communicate also lacks uniformity and is instead largely multifaceted, often contradictory, and ambiguous. Our thoughts about both ourselves and others differ depending on context, which implies that our communication is adapted to the situation and the roles or identities that it activates. If we are not well-versed in the art of being present and authentic in communication, something that is dealt with in chapter 7, we are not likely to communicate in the same manner when a police officer stops us when speeding, and when we interact with parents, friends, or colleagues. Communication is inherently context sensitive, and that is one important reason why communication handbooks and advice based on well-nigh static personality types are not very constructive (though admittedly appealing with their apparent but in the end still reductionist nod to what is familiar).

In sum, it is helpful to remember that when you have a thought about me, this is something you have created yourself. You have turned me into an idea that you believe in, and it is when you act communicatively on this idea that the conflicts risk arising. This type of conflict often has the character of a competition, a struggle over who is right and who is wrong, where victory becomes the goal of communication. It is also often a matter of shifting the burden of guilt so that you can perceive yourself as innocent or as a victim and therefore as the better party. However, the entire struggle to determine right and wrong, guilt and innocence, seems redundant when considering the quote that introduces this chapter. The thoughts we perceive as true are based on one of many possible perspectives and when communication turns into a competition it is usually the misleading attributions that determine the course of communicative action. We simply forget or find it unnecessary to keep an open mind to the thoughts and ideas in our heads and instead we mistake them for the truth.

If you, nonetheless, come out of the communicative struggle as the "winner," this does not automatically mean that your perspective is the right one. It may simply be that you have better access to the communicative tools than your

"opponent." Many people have built a substantial portion of their self-confidence precisely on the ability of argumentation and being right and have turned this into an almost compulsive need. But this skill, which we (and unfortunately large sections of society overall, not least in politics) perceive as a strength, in fact constitutes a weakness when it comes to our ability of creating and maintaining trusting and harmonious relationships. The very idea of right and wrong is based on a dualistic thought pattern, and the argumentative and oppositional communication style creates a separating hierarchy, which makes impossible the equal relationship required for trust to evolve.

Obviously, it can be frightening to let go and admit that we do not know what we think we know, not about ourselves, not about the world, and not about the people with whom we are communicating. But when we remain open to and curious of what is happening in the here and now, we set the stage for trust-building communication. As Adyashanti (2013, p. 148) suggests, "when we realize that what we think and say isn't the ultimate truth, then what we think and say can always adapt itself to the moment." But when we instead believe in our conceptions about the world and about other people, which are filtered by our previous experiences, we effectively transform the present into a repetition of the past and block the communicative flow and lightness with our attributions. And last but not least, consider this: what if it is through the unknown that we actually come to know?

Tolle (2011) suggests that there are ultimately only three ways to handle a challenging (communicative) situation:

1. Accept the situation instead of resisting it. Acceptance is a fundamental prerequisite for obtaining peace of mind and trusting relationships and is further developed as the final ethical principle.
2. Change the situation by opening your mind to the possibility that the other person's perspective might be just as valid as yours. As Lindeblad and colleagues (2022) remind us: it is wise and also truly liberating to admit that "I may be wrong." Or neutralize the communicative tension through humor and new angles.
3. Leave the situation if 1 and 2 are not applicable. If the current situation contains (communicative) violence in any form, there is definitely no reason to stay. Nevertheless, we will most likely have to deal with what has transpired at some point in order not to get caught in guilt, victimhood, or remorse. This is addressed more thoroughly in the next chapter. If the challenge is more of an everyday nature, but we find it difficult to apply 1

or 2, we might leave the situation for now but return at a later point. We trust that the wisdom within will provide guidance on how to (re)create harmony in the relationship, and when we again feel deeply rooted in the Now and the thinking mind has melted into the heart, we realize that the separation that we for a brief moment experienced is not real. We know that the bond to the other person is still unbroken, and that our communicative differences should be seen as a cry for love. Based on this innate knowledge, the natural next step will be to communicate compassionately and with an open mind.

Once we have reconnected with the wisdom of our innermost being, it is quite plausible that we discover that we do not really need to "correct" the other's opinions, interpretations, or impressions. When closely tied in with the all-pervading wisdom and compassion, we intuitively know that the situation does not require any response from us and realize that we can completely let it go, while maintaining peace of mind. If we still want to convey our thoughts and feelings, we are certainly free to do so, while taking full responsibility for our interpretations and showing awareness that they build on *our* perspective of the world. We are open, honest, and authentic and communicate without attack and with a humility and an openness to the fact that there may be other equally valid perspectives. Carlsson (2014, 11 February, author's translation) illustrates this as follows:

> We are just humans, and we often misunderstand life and each other. You do it, I do it, your partner, your friend, and your co-worker, they all do it. It is a relief to stop putting too much faith in our own experiences and perceptions of things. What we see and perceive around us are often just mirror images of our own anxiety and division.

The *Bible* quote "Blessed are the meek, for they shall inherit the earth" (Matt. 5:5, ESV) makes evident the importance of humbleness (meekness) in a world which is sustainable in every respect. Meeting others with the humility of the open mind also means that we rid ourselves of our defensive tendencies, which is further developed in the next chapter.

# References

Abram, D. (1997). *The spell of the sensuous: Perception and language in a more-than-human world.* New York: Vintage Books.

Adyashanti. (2013). *Falling into grace: Insights on the end of suffering*. Boulder: Sounds True Inc.

Carlsson, O. (2014). *Just idag: 365 tankar för sinnesro* [*Thoughts for the day: 365 Reflections for peace of mind*]. Stockholm: Bonnier Fakta.

Hall, S. (1995). Cultural studies: Two paradigms. In O. Boyd-Barrett & C. Newbold (Eds.), *Approaches to media: A reader* (pp. 338–347). London: Arnold.

Lindeblad, B. N., Bankler, C., & Modiri, N. (2022). *I may be wrong: And other wisdoms from life as a forest monk*. London: Bloomsbury Publishing.

Peirce, C. S. (1992). *The essential Peirce: Selected philosophical writings (1867–1893)*. Bloomington: Indiana University Press.

Saussure, F. (1959). *Course in general linguistics*. New York: McGraw-Hill.

Tolle, E. (2011). *The power of now: A guide to spiritual enlightenment*. London: Hodder & Stoughton.

# 6

# Defenselessness

Whenever you are confronted with an opponent. Conquer him with love.[16]

Obviously, it is not always easy to communicate in ways that support the growth of trust when we feel unfairly treated and misinterpreted. It is pretty hard to stay open minded and compassionate in situations where we seemingly have been accused and found guilty. Or when other people's communication reflects worldviews, which we find repulsive, ignorant, or naive. Few people today have developed the ability to listen deeply and distance themselves from the various needs of the ego (not least to be right), and it is undoubtedly a challenge to refrain from defending ourselves in situations we find provocative.

The previous chapter suggested that communication in its essence is neutral, since words as well as body language and tone are only constructions of sound and form; empty signifiers, to which certain culturally and individually conditioned meanings have been ascribed. We can never understand other people's communication in a completely untainted manner, where their messages, thoughts and motives are perfectly transparent and comprehensible to us. But we do have the ability to identify our own interpretations of what is being communicated, which is why we must take responsibility for our reactions to and feelings about it. "No one can harm me without my permission," allegedly was Mahatma Gandhi's

---

16 Quote commonly attributed to Mahatma Gandhi.

way of expressing this responsibility. To fully embrace and accept ownership of uncomfortable feelings, even though internal resistance probably arises and stays for a while, is perhaps the most important thing in practicing defenselessness. As we begin to understand its significance, we gradually cease to locate the cause of our pain and discomfort outside ourselves and instead start looking within.

The principle of defenselessness thus means that we accept responsibility for our meaning making by not logging into and identifying ourselves with the more or less automatic and unreflected interpretations and assessments of other people's communication. What is required first and foremost for this to happen, is to be deeply rooted in the present moment, in the deep listening, and to accept what takes place communicatively. Instead of building an internal wall of resistance with which the communicative flow collides ("I don't agree with this!" "That's a total misunderstanding!" That's not what I meant!"), we allow the challenging words to flow right through or past us. Based on the anchoring in the Now, we can look at our interpretations and the related feelings with compassion and let go of the impulse to defend ourselves, our perspectives, or our actions. No drama—just a tiny bit of distance between You and your (ego's) reactions.

## Judgment and Attack

Rosenberg (2003) identifies a number of obstacles to the development of compassion and open-mindedness. The greatest of these, according to him, is our tendency to judge ourselves or others, when we or they do not act in accordance with our enculturated worldview and our deeply ingrained values. The ways of communication we learned as children, which we more or less take for granted, encourage us to blame, criticize and compare, all of which effectively prevent trusting compassion from taking communicative form.

This means that we need to put our inclinations to judge and attack others as well as to defend ourselves under careful scrutiny. It is relatively easy to grasp that direct attack on another person without prior provocation is devastating for the (re)generation of trust. But the fact is that defenselessness also—and to an equal extent—includes that which we would like to define as legitimate defense: "You have completely misunderstood my intention with this!" "Your accusations are utterly foolish!" In the dualistic thought and communication systems we are used to, a distinction is in this manner made between defense, where we respond to a perceived attack from another person, and attack, where we ourselves initiate the confrontation. However, when practicing the defenselessness principle, we avoid

them equally, because both result in a communicative breakdown. Offensive as well as defensive attack presupposes that we have first judged the other person's (communicative) actions as undesirable, and that attack thoughts have arisen. The separation—the experience of being isolated from the other the person (which created the harm in the first place)—is (re)produced in thought and projected from there onto the world. Furthermore, anger in all its forms, from little stings of irritation to uncontrolled rage, clouds our judgment and we lose the ability to choose between what is wise and what is not. Instead of going to counterattack, we might recall the words of Jesus: "But I say to you, Do not resist the one who is evil. But if anyone slaps you on the right cheek, turn to him the other also." (Matt. 5:39, ESV)

Nonetheless, there is one type of anger that acts as a driving force for the long-term development of trust, namely the anger that comes directly from our innermost being, where we experience the interconnectedness of all life forms, and where we intuitively know that All is One. When the behavior of others in one way or another violates some aspect of this seamless whole—human as well as non-human lifeforms—we experience the violation as if it were done to us. Spira (2017) proposes that this type of anger, which is not ego-based but emerges from the true, nondual foundation of all existence, constitutes a fully legitimate "sacred outrage." And we do recognize it in the *Bible's* descriptions of how Jesus felt when he saw people dishonoring the message of love. So, when we witness cruelty to animals, massive deforestation, or abuse of people, and when we feel our hearts breaking and desperation and anger arising, this would simply be a genuine response to the violation of the oneness of universal love.

For the vast majority of people, however, it is difficult to discern and identify the ego's manipulative reactions in the everyday irritable moments—at work, in the family, at school. Therefore, until we are absolutely certain that it is "sacred" outrage we are feeling, we do best in taking a few deep breaths and allowing relaxed attention to sink into the inner stillness, where the wisdom to distinguish what to communicate or do, if anything at all, is available.

Apart from its "sacred" mode, anger in its various forms is something we need to deal with if we want to practice communication that stimulates trust and the experience of interconnectedness. In particular, it is important to be attentive to judgmental and attacking thoughts that come from an imagined victim position, where "I"—the ego—am treated unfairly: "He's never satisfied even though I always do my best!" "She should be grateful for what I've done!" "If I am to pay such high taxes, at least I should be able to expect better service!" The same applies to those haunting thoughts that tend to revolve around what we should

have said or done in a challenging situation that has already passed. Replaying a previous communicative situation in our minds, where we imaginatively express the things that we *really* should have said to feel satisfied with what has occurred, is of course an immense waste of energy in its pointlessness. But above all, it effectively removes us from the present moment, which is the actual rescue from the unpleasant thoughts and feelings evoked by the communicative encounter. To communicatively "punish" someone in a fictitious situation that solely takes place inside the head is not only ineffective but also results in the reproduction and perhaps even the intensification of the original discomfort. Instead of resorting to this kind of simulated communication, acknowledge the upset feelings, pay alert attention to them without labeling them, and embrace them with compassion. Then allow them to burn with their own intensity without judging, changing, or avoiding them. Staying open to whatever arises within is the only way to realign yourself to the inherent peace within (Spira, 2016).

The virtually automatic judging and evaluating of the ego are almost constantly present in our minds. A judgment can of course be rough and of an obvious attack-character, but it does not have to be so in order to function as such. Thoughts that seem to come so natural to us that we take for them granted, could also be seen as judgmental; we assess what people look like, what they wear, how they act in everyday situations, how they express themselves, and so on. But instead of getting caught in the patterns of spontaneous judgment we might try to view the "battlefield" from outside or from above and in this way avoid becoming part of it. Because do we really have what it takes to judge correctly? Do we have access to all perspectives of the past, all scenarios of the future? Do we, quite simply, have the resources to see the bigger picture? I think not.

From the *Bible* (Matt 7:1–2, ESV) we recognize the ethical principle "Judge not, that you be not judged. For with the judgment you pronounce you will be judged, and with the measure you use it will be measured to you." A common (mis)interpretation of this quote is that a punishing God (in human form) on doomsday will judge us in the same way we have judged others. But from the nondual point of view, where we see all aspects of the whole as intimately intertwined, we can understand the quote differently. When you pass judgment on me, you also pass judgment on yourself, because the boundary between you and me is illusory.

Instead of judging, Rosenberg (2003) suggests that we stay present, observing and noting but not evaluating what is communicatively going on. Or perhaps, more accurately, that we observe and note the judgment when it arises, as it tends to occur rapidly and unintentionally, but refrain from believing in and

acting upon it. From this neutral position of pure observation, it is even possible to distance oneself from the positive judgments, because all judgments and evaluations—also the ones that we perceive as kind and supportive—are dualistic in nature, which means that they cannot exist without their opposite. Judgment thus effectively keeps us chained in the world of opposite. In the *Bhagavad Gita* (6:7–8), people who have overcome the attraction of dualistic judgment are described as follows:

> To such people a clod of dirt, a stone, and gold are the same. They are equally disposed to family, enemies, and friends, to those who support them and those who are hostile, to the good and the evil alike. Because they are impartial, they rise to great heights.

But, of course, positive judgment is still preferable to negative, because in a transitional period it can replace the negative evaluation and thus facilitate communication that supports trust and the experience of interconnectedness.

## Cause and Effect

As individuals we have different dispositions, experiences and abilities that aid or obstruct the acceptance of the communicative situation as it develops. They also aid or obstruct the advocated detachment from the ego's constant judgments. We also find this easier or more difficult depending on the situation; communication is, as already noted, context sensitive. But the fact remains: in order to communicate defenselessly, we need to take responsibility for our interpretations and reactions. It is extremely easy, and therefore also very common, to situate this responsibility on the outside—with the other person or the external circumstances—and accordingly find it completely natural and justified to go on the defensive/attack. But just as Rosenberg (2003) observes, the communicative actions of others function only as stimuli for our reactions, they are never the cause of them. The real reason for the negative feelings lies within in the form of thoughts and past experiences. So even if we were to deal with the "cause," which we perceive to be external to us—the other person may accept the blame for the problem—the real cause will remain within us in the form of attack thoughts. These will continue to produce effects of exactly the same kind, that is, other people's communicative actions will appear unpleasant to us. As Easwaran (2007, p. 43) in the *Bhagavad Gita* points out, "Just as a seed can grow into only one kind of tree, thoughts can produce effects only of the same nature."

One could even claim that it is our thoughts that *create* the reality we experience; that thoughts are the cause and the world we perceive is the effect. This, as one might spontaneously think, reverse chain of cause and effect means that instead of placing the cause of our reactions outside ourselves ("Since she's so condescending to me, it's only fair that I avoid her!"), we realize that the real cause of our discontent resides within us as attacking thoughts and projections.

If you still doubt the creative power of thoughts, take the example above, "She's condescending…," and ask yourself the simple question how it would feel to let go of that thought. The probability is high that you quite spontaneously answer "so good!" It does not have to be more difficult than that. Much of the pain we experience and that prompts our communication are just thoughts, which we believe in and identify with. In many instances, these thoughts have even become more important and real to us than what actually has happened (Tolle, 2011). Instead of sticking to the facts, for example "She didn't answer when I spoke to her," we add our own interpretation, in the current example that "She's condescending to me." If we let go of these interpretations and stories and focus only on what in fact happened or did not happen, we also get rid of a lot of emotional discomfort as well as the need to judge and attack others.

This sounds easy enough, but we still have to be prepared that the ego always wants to go into some kind of defense to protect itself. The ego never wants us to turn attention to the inside and seek the real reasons for our reactions, because—if revealed—those reasons would make it vulnerable in its specialness. For the sake of its own survival, the ego wants to continue to divide, separate and maintain polarizations and thus the conflicts. Therefore, we must stay vigilant of the ego's demands, and instead of habitually arguing, getting defensive, or giving way to toxic silence, simply listen in deep presence without interrupting. If we let our fellow human being express everything they need, we avoid a communicative breakdown or, for that matter, that the argument turns into something completely different from what it was originally about, which is otherwise a rather common development. If we feel that some type of response is necessary but find it difficult in the concrete situation to formulate our feelings and thoughts in a responsible and compassionate way, we can always delay this to a less infected occasion. And when we in due course express ourselves, we do so from a defenseless position that allows the situation to neutralize rather than escalate into attack. In general, we hardly know anything about why people communicate in a way that we perceive as aggressive, unfair, or rude, and when we practice this ethical principle, we take responsibility for ending the negative communicative spiral here and now.

As a matter of fact, when we have patiently listened and waited, we realize more and more often that the original need to speak our mind or make defensive corrections simply vanishes. We recognize that it was only the ego that reacted and felt hurt by the other's ego and that the deep Self was not at all harmed by this, as we thought, incorrect or perhaps unfair interpretation or accusation from the other person. With a little practice, we remember that what we think is a fair and legitimate defense is based on our own opinion of what is "fair and legitimate," and that this opinion is usually not generally valid but cultivated by our socio-cultural belonging and personal experiences.

## Guilt and Forgiveness

Much of the discomfort we experience when communicating with other people is about wanting justice and thereby attributing guilt. But, when practicing the defenselessness principle, we refrain from judging and evaluating people and consequently also from blaming them, because equality is a necessary condition for the growth of trust. If the other person in the communicative situation "loses" by being expected to shoulder the burden of guilt so that we (or rather our egos) can maintain the self-image as the "good" party, hierarchy and asymmetry will characterize the relationship. Such inequality is harmful not only to the other person but also to us, as the feeling of separation and isolation is reinforced. When we instead have trust and faith in the good in the other person, we also include ourselves in a trusting atmosphere. Since the boundary between you and the other is in an interconnected reality illusory, the guilt you assign to or the trust you show another person also become your own. The logic is simple. In this way, the principle of defenselessness always aims to dissolve the dualistic relationship between guilt and innocence, which concretely means that we expect to see innocence and goodness everywhere.

This is undeniably a challenge in the coarse, polarized world we have created, where goodness is often dismissed as old-fashioned, naive and ridiculous, and condemned by some people in the public debate as phony and only used to strengthen one's "goodness" persona. In my own generation, people in Sweden used to mockingly claim that "cows are kind too," and to avoid the comparison to a cow (as if this would be so terrible!) one did best in avoiding kindness. Fortunately, Einhorn (2007) broke this vicious circle and highlighted goodness as something worth striving for.

In fact, Lent (2021) displays compelling evidence from several studies that people *are* inherently good. From infancy, humans are bestowed with an innate sense of fairness, altruism, justice, compassion, and generosity as well as an ability to distinguish between kindness and cruelty. And it is from this premise—that we expect our fellow human being to be decent and innocent—that trust is generated, and that is why goodness cannot be dismissed with cynical arguments. It is this type of reasoning that has so far triggered the patterns of attack and conflict to take increasingly extreme forms on both individual and societal levels. Attack is never the best defense, no matter what.

Habitually erecting barriers of blame and guilt takes an enormous amount of energy and is perhaps the main obstacle to the experience of interconnectedness and trust. If we want the world that we experience around us to change and become harmonious and trustful, we must be this change ourselves. Note that Mahatma Gandhi, who allegedly uttered these words, did not say that we had to *do* anything in particular to change the world, but simply that we should *be* the change. So let go of your stories, let go of your judgments, let go of your thoughts of retaliation, and let go of your thoughts of attack. Just stop and remain in the core of stillness within and discover that right here—in your effortless being—the harmony and trust that you seek are already available for you to connect with. Know that this belongs to you!

Firmly grounded in this vast place of space and silence, we can communicate without accusing, criticizing, comparing, and blaming, and instead listen deeply to our fellow human being. Is this person communicating love or are we listening to a cry for love? And, if the latter is the case, what needs might lie latent behind these words of despair? Can we perhaps, as Rosenberg (2003) suggests, compassionately affirm that we understand those needs, which of course does not mean that we have to sympathize with them? In each moment, we decide that in the choice between defenselessness and attack, we choose the former. And when we fail, as we are bound to do although it will become less frequent over time, we choose defenselessness again and do not blame ourselves.

Defenselessness and avoidance of assigning blame is, of course, intimately connected to what has come to be known as forgiveness. In Christian ethics, as in the vast majority of wisdom teachings, forgiveness has a prominent position, but for many of us it is difficult to grasp and make sense of. Can I forgive everything? How do I do that? And how do I integrate forgiveness within me, so that it becomes sincere and not just empty words? Maybe you among many others think of forgiveness as an opportunity, where you graciously forgive another person for a wrongdoing they have subjected you or someone else to. The dream scenario

would then be that the person in question acknowledges the wrong done, takes the blame, begs for forgiveness and that you, from your superior position, accept to forgive. The other person is at disadvantage and your ego can boost itself with righteousness.

But true forgiveness never makes us bigger and better than anyone else, because equality—again—is a prerequisite for trust. Consequently, we refrain from creating such asymmetry in the relationship, and view forgiveness as an honest and wholehearted attempt at *shifting perspective*. Instead of seeing the other person as an enemy and placing the burden of guilt on their shoulders, we decide to see the tangled (communicative) situation differently. Experiences from the past exist only as thought forms, and the future exists only in the imagination, so we let go of both. Grounded in the Now, we take another look at our fellow human being and see them in a new light, because we know that they are acting out of unconsciousness and not out of the essence of who they truly are. Thus, forgiveness in this mode carries significant similarities with the forgiveness that Jesus expressed on the cross when he said: "Father, forgive them, for they know not what they do" (Luke 23:34, ESV).

In the book *Wabi Sabi* (2011), Nyholm refers to a particular occasion when she met a group of young unemployed people. One of the participants—a young man, who gave anything but a spiritual impression—frankly stated that in order to create good relationships, doing things "Jesus style" is most important. By "Jesus style," he meant to reconcile with and forgive whatever takes place. In the book he is quoted as follows:

> If you don't reconcile with what's happening, you'll be walking around with a bunch of chairs and tables on a rope around your neck. You can't move very quickly, it hurts all the time and you are so busy dealing with the chairs and tables that you hardly see what else is going on ... The choice is yours—the result is yours. (Nyholm, 2011, p. 29, author's translation)

So, for the sake of our own peace of mind, we do not demand that the other person takes the blame and asks for forgiveness but simply decide to see us as intertwined and as one instead of divided and separated. And it is when we turn inwardly to the comforting rest in the Now—to the deep Self, freed from time and space—that we experience this.

Notice that there is always an opportunity, everywhere and at any time, for such a shift in perspective; to decide here and now to see the situation or the person differently and let go of judgment, blame, defense, and attack. In a way, you

can say that we thereby forgive, not other people, but ourselves for our judgment of them. And what in our innermost being, beyond our egos, do we really have to lose by opening our minds to such forgiveness? After all, it is the only path that leads away from the discomfort and pain that the separation inexorably causes. As some wise person once put it: Resentment is like taking poison and waiting for the other person to die.

Obviously, this does not mean that we should let other people treat us badly. There is nothing in the nondual foundation of the communication ethics proposed here that justifies us becoming passive spectators when we or our fellow beings are mistreated. Relationships and situations that, for example, involve violent actions—physically, psychologically, economically, communicatively—should of course be changed or left. But this may be easier said than done. Consequently, it is important to not only, or even primarily, forgive the other person, but—just as when it comes to compassion—start with and forgive yourself.

Earlier in this chapter it was established that the (communicative) actions of others are not the main cause of our painful experiences, but that the cause also lies within ourselves in the form of repressed feelings and past experiences. Tolle (2011) labels the hard knot of accumulated suffering the "pain body," and other people's behaviors most often activate all or parts of it. This makes us believe that it is other people—the external circumstances—that are causing our suffering, when in fact it is the pain body, which we already carry within, that has awakened. It may even fetter us in the unwanted situation because it makes us think and feel that we do not deserve better.

In order to break the pattern of suffering, the repressed emotions, which together constitute the pain body, must gradually come to the surface. But not through attack on another person. Instead, we try to connect with these feelings when deeply rooted in the wordless stillness within. In this place we can direct our focused but relaxed attention to them and allow them to take the shape and expression they need. In this place we can choose to truly love and embrace all our broken parts (as we perceive them) without analyzing or labeling them. In this place we can offer them our deepest and most generous and forgiving compassion. This is our ability, and it is our choice to do so, not just once but again and again until the intense pain consumes itself. When we deeply acknowledge and forgive the voices, actions, and thoughts of the past, which have amalgamated into the pain body, the knot of suffering slowly and gradually dissolves. We no longer believe that we are worthless and that we deserve to be mistreated or ignored. Concomitantly with the dissolution of the pain body in forgiveness,

the power that truly belongs to us is released and enables a radical change of a destructive life situation.[17]

Forgiveness, both in the form of shifting perspective and self-forgiveness, is highly relevant also in retrospect when we have to deal with the thoughts and feelings about hurtful experiences. Through forgiveness, we can avoid reproducing the anger, the accusations and the blaming and thus escape the diminishing and paralyzing role of the victim. Through forgiveness we escape fear. The words allegedly expressed by Nelson Mandela when released after 27 years in prison for his opposition to the apartheid regime in South Africa, illustrate this in the clearest possible way: "As I walked out the door toward the gate that would lead to my freedom, I knew if I didn't leave my bitterness and hatred behind, I'd still be in prison."

And we can honestly wish for the person or persons we associate with the destructive situation to experience peace and love, because peaceful and loving people do not harm other sentient beings. In this context, the Buddhist metta meditation, which is about loving-kindness, can be of great help. Below is suggested a variation of this meditation, which is performed mindfully in intense contact with the deep Self. And as usual, we start with ourselves.

May I be well, may I be happy, may I feel peace.

May you (name of person) be well, may you (name of person) be happy, may you (name of person) feel peace.

May all beings be well, may all beings be happy, may all beings feel peace.

Forgiveness is thus the only effective means to end our own suffering by fully and compassionately embracing the unity of the Now instead of reproducing the separation of the past. Ultimately, this means that forgiving is indistinguishable from accepting a wholeness that knows no parts, or, in other words, overcoming the world of opposites.

## References

Duprée, U. E. (2012). *Ho'oponopono: The Hawaiian Forgiveness Ritual as the Key to Your Life's Fulfillment*. Baden-Baden: Earthdancer Books.

Easwaran, E. (2007). Introduction. In *The Bhagavad Gita* (E. Easwaran, Trans., pp. 7–67). Tomales, CA: Nilgiri Press.

---

17 For an in-depth guidance of this type of self-forgiveness, see, for instance, the Hawaiian forgiveness ritual Ho'oponopono (Duprée, 2012).

Einhorn, S. (2007). *Konsten att vara snäll* [*The art of kindness*]. Stockholm: Månpocket.

Lent, J. (2021). *The web of meaning: Integrating science and traditional wisdom to find our place in the universe.* Gabriola Island, Canada: New Society Publishers.

Nyholm, A. (2011). *Wabi sabi: Tidlös visdom* [*Wabi Sabi: Timeless wisdom*]. Stockholm: Norstedts.

Rosenberg, M. B. (2003). *Nonviolent communication: A language of life.* Encinitas, CA: PuddleDancer Press.

Spira, R. (2016). *Presence (volume 2): The intimacy of all experience.* Oakland: New Harbringer Publications.

Spira, R. (2017, January 20). *The sacred outrage* [Video]. YouTube. https://www.youtube.com/watch?v=IR6nDfHR5HY

Tolle, E. (2011). *The power of now: A guide to spiritual enlightenment.* London: Hodder & Stoughton.

# 7

# Truth

The only language able to express the whole truth is silence.[18]

The next principle is perhaps the most difficult to interpret and to deal with, namely, what should be considered as true and how we should communicate this truth. In the previous chapters, truth almost got lost in relativization when they established that all people view the world from their own individually and culturally conditioned perspectives; the cognitive "filters" through which we interpret our sense impressions. Meaning, whether it concerns the world we perceive around us or other people, is never given but attributed. Thus, what we perceive is strongly colored by our past, and when we value something as true there are no guarantees that others will make the same assessment. Determining what is objectively true is therefore very difficult, and philosophers have struggled with this concept since the dawn of time.

## Different Kinds of Knowledge

To begin with, we can ask ourselves whether different kinds of knowledge might carry different levels, or degrees, of truth. Well, scientific knowledge based on

---

18 Quote commonly attributed to Ramana Maharshi.

independent research claims to be more truthful than everyday knowledge because it builds on knowledge that is already scientifically verified. Knowledge production is thus assumed to be cumulative and also generalizable in various ways, which means that it is not restricted to individual experiences or particularized phenomena. Scientific knowledge is produced with methodological systematics, which strengthens its *reliability*, and with tools that are capable of answering the research questions, which guarantee its *validity*. Science usually legitimizes its knowledge claims through the correspondence theory, that is, that the knowledge that corresponds to a certain factual situation in an external reality is to be regarded as true.

However, scientific knowledge cannot claim that it is true beyond human perception and analytical capability. Modern science—including the humanities and social sciences—is to a significant extent characterized by the knowledge theory (*epistemology*) known as empiricism, which means that only what we can experience with our senses, may count as knowledge. As Lent (2021) argues, this narrow (and anthropocentric) view of the world has led modern science into the fallacy of ontological reductionism—it has confined what *is* to that which human perception can capture, and the human mind can grasp. It is true that there are epistemological traditions in the humanities and social sciences, such as critical realism and grounded theory, that look beneath the empirical surface to identify structural conditions that (re)produce different kinds of materiality and interconnections. But they, too, are epistemologically confined to the world of form and dismiss the sheer possibility of any other reality. Furthermore, since forms are constantly changing, scientific knowledge is also changing, and new research continually disproves the previous. As researchers, we can claim that "this is the best knowledge we have right now," but we can never guarantee that it is completely true. There is always a certain amount of uncertainty even in science.

By scientific standards, everyday knowledge is less valid because it is unsystematically produced and based on individual experiences and, not least, feelings. What we today have come to call the post-truth society constitutes a shift from the scientific norm of truth to the everyday, where the two have, if not swapped places, at least become more equal. Along with the rapid expansion of digital media, even lies and propaganda have to some extent been normalized in post-truth society. Despite a non-existent or low degree of truth, their potential to take root should not be underestimated as the devious content is fueled by people's lack of trust in each other, their environments, and by the related feeling of separation.

In the digitized mediascape, propagandistic disinformation, that is, pure fabrications aiming to create division and polarization, thrives. Obviously, propaganda has always existed, but with the rise of social media and people's unaccustomedness to being their own gatekeepers, it has run wild. Since there is a great deal of literature dealing with the process toward post-truth society (e.g., Lockie, 2017), there is no need to probe deeper into this here. It suffices to say that there are different kinds of knowledge that operate at different levels of what we perceive as reality, and that their positions as "representatives" of the truth may be relatively stable, but not static or unchallenged.

## The Absolute Truth

If modern science can only be said to produce contingent knowledge about reality, and if everyday knowledge is not generally valid, does this mean that there is no eternal truth? Is there no truth that remains unmoved and universal regardless of what happens or does not happen empirically in what we perceive as the world?

Based on the nondual, integrated ontology, where everything is viewed as interconnected in an indivisible whole, the answer is yes, it does exist! The absolute Truth is that all things and all life are united in One, and that this eternal and infinite One takes on a myriad of forms of perishable and ever-changing matter, which we conceptualize as the "world." From the nondual outlook, anything that reinforces the experience of separation and changeability is simply untrue. In communicative terms, this would mean that a statement such as "There is no separate self" is communication of an absolute Truth, as Thich Nhat Hanh (2013, p. 63) suggests. This statement does not allow for any kind of interpretation or change; it is an expression of nonduality, and it is eternal.

The ego as described in the previous chapters, stands in stark contrast to this absolute Truth because it consists of the very idea of the self as a unique, special, and separate *person* with distinct personality traits: "I, Robert, am a funny and rather stubborn person." "You, Chris, are very bitter." This personality is, however, far from fixed, but should rather be seen as a process in constant transformation during a lifetime. Robert may well have been shy when younger, and Chris joyful. Experiences are added to experiences, and the personality together with its attached roles ceaselessly takes on new forms and expressions.

> At different times and in different company, the same person seems to have different personalities. Moods shift and flicker…; desires and opinions change with

> time. Change is the nature of the mind…The parts do not add up to a whole; they just flow by…Just as the world dissolves into a sea of energy, the mind dissolves into a river of impressions and thoughts, a flow of fragmentary data that do not hold together. (Easwaran, 2007, p. 25)

In the light of the absolute Truth, we are approaching the realization that this separate self—the personalized ego—is not the ultimate truth of who we are. As noted in chapter 1 it is the *Ahamkara*, the not-self. Admittedly, the fragmented, rapidly changing world inhabited by such separate selves *is* true when viewed from the lower level of consciousness, where most of us still remain. But the absolute, ultimate, and eternal truth is the interconnectedness, the oneness; there are no dualities, no differences, no change, no contrasts, and no ambiguities.

The moment we know—not primarily intellectually but in direct bodily experience—that there is only one consciousness and that we are all inseparable, intertwined parts of that consciousness, we reach a higher level of knowledge, and a more advanced and integral ontology emerges. When duality collapses, we experience the state that in yogic philosophy is called *samadhi* and in Zen Buddhism, *satori*—the highest state of mind. This is the absolute Truth, and to experience this we need to turn deep into our innermost being.

> You must grow and evolve in your capacity to perceive the deeper layers of your Self, which disclose higher levels of reality: the great within that is beyond: the greater the depth, the higher the reality. (Wilber, 2000, p. 189)

In relation to the absolute Truth, human communication falls rather short. Words and concepts are only labels or symbols and can therefore never encompass it. For this reason, it can also be argued that Truth lies beyond our ability to communicate. To "believe" in words and concepts is to constantly deceive ourselves. Every time we open our mouths to speak, the tyranny of duality tends to restart because of our polarized and contrasting language system, at least when we communicate unconsciously, which most of us do all the time.

Just as the quote that opens this chapter suggests, it is not through words but through silence that we best communicate Truth. Who we fundamentally are, beyond ego or personality, can only be experienced when we are fully present and grounded in the stillness within, detached from the objects in our attention field including emotions and thoughts. It is in this quiet, wordless place that we can experience the interconnectedness and thus attain the highest form of knowledge. This limitless experience, where silence is predominant and the dualism I and You (Buber, 2013) becomes meaningless and without substance, is illustrated

below through the words of a few wise individuals with roots in different times and backgrounds:

> Out beyond the ideas of wrongdoing and rightdoing, there is a field. I'll meet you there. When the soul lies down in that grass, the world is too full to talk about. Ideas, language, even the phrase "each other" doesn't make any sense. (Quote commonly attributed to Rumi)
>
> Solitude is for me a fount of healing which makes my life worth living. Talking is often a torment for me, and I need many days of silence to recover from the futility of words. (Quote commonly attributed to Carl Jung)
>
> See how nature—trees, flowers, grass—grows in silence; see the stars, the moon and the sun, how they move in silence … We need silence to be able to touch souls. (Quote commonly attributed to Mother Theresa)
>
> We're fascinated by the words, but where we meet is in the Silence behind them. (Quote commonly attributed to Ram Dass)

It is not the aim of this book to convince anyone of the absolute Truth on a conceptual or intellectual level. It can hardly be captured through the methods of empirical science either. And when old, deeply ingrained communicative behaviors are triggered by the various challenges of everyday life, it is quite difficult to keep these kinds of abstract truths in mind, however absolute they may be. In what follows, I elaborate instead on the ways truth can be handled communicatively to (re)establish trusting relationships in an existence characterized by highly worldly conditions, demands and expectations. And, more importantly, even if we know the absolute Truth, we must, as Thich Nhat Hanh (2013, p. 58) puts it, be able to speak "the language of the world."

## The Lie

In a dualistic system of thought and language, the lie stands in opposition to the truth. Obviously, to have peace of mind and (re)create harmonious and trusting relationships, it is essential that we do not lie about our actions, thoughts, or feelings. Not to be untruthful in the sense of lying is something that most people are taught at an early age, and the idea of lying as something bad usually serves as a general moral compass. Of course, this moral compass should not be used to legitimize a "truth-telling" that is as indiscriminate as it is merciless, that is, to express everything we perceive as true regardless of how it lands on the

other person. In accordance with *Ahimsa*, the principle of non-violence, the truth should not harm another human being. Since words are not neutral but hold enormous power to create the world that we and those around us perceive, they must be handled with utmost care. We recall the three pieces of advice given in chapter 2 and ask ourselves the latter questions before we express anything under the pretext that "I'm only telling the truth!"

Is it necessary?
Is it kind?

Needless to say, the reverse relationship is also inapt, that is, to let the principle of *Ahimsa* legitimize so-called "white" lies. Whether the lies are big or small is irrelevant. Nor should *Ahimsa* be used as an excuse to deliberately withhold the truth, when we really are protecting ourselves from discomfort. In such cases, it is about us not being courageous enough to take responsibility for our actions or thoughts rather than sparing another person from pain. This may sound obvious, but it is very easy to fall into the trap and deceive yourself. So, hand on heart! If you can lie just a little bit, and do so in a credible and convincing way, are you not inclined—at least sometimes—to justify this refined lie as almost as valid as the truth? You might even feel indignant if you are not believed, because the lie you communicated so ingeniously and realistically could have actually been true.

Be that as it may, it is likely (as always) fear that constitutes the foundation of both lies and self-deceptions. We are simply afraid of what will happen if those around us find out what pitiful and corrupted people we really are behind the innocent mask we are wearing and the righteous role we play. Carlsson (2014, March 30, author's translation) illustrates this in a clarifying way:

> I don't think us humans want to lie to each other, often we lie because we believe the truth will have consequences we cannot control. In situations where we feel inadequate, threatened or afraid, we can fabricate the most sophisticated and elaborate lies, but we only lie because we are afraid. Lies are nothing but fear. In an atmosphere of trust, we dare to be more honest.

Obviously, we are more likely to be honest and truthful in a trustful atmosphere. The question is how trust will grow in soil where lies proliferate and perhaps are even normalized.

## Consistency and Authenticity

Once established, the vicious circle of lies and lack of trust is very difficult to break. But when practicing the truth principle, we still make an attempt by dividing honesty, which is of course closely related to truth, into two components:

Consistency—being one with yourself

Authenticity—being genuine and transparent

According to the principle of *Satya*, which means "truth" and like *Ahimsa* is one of the main ethical principles of yogic philosophy, we are honest when what we a) think, b) say and, c) do are in complete harmony. This illustrates what honesty in terms of consistency entails here. In order for us to be one with ourselves, which is a prerequisite for the experience of interconnectivity with a larger whole, there must be agreement between thought, word and action. When this harmony exists, we do not experience any conflict or confusion within us on any level, neither emotionally nor mentally. This, in turn, enables a communication that stimulates trust instead of uncertainty and fear. We are in harmony with ourselves, which is never the case when we are inconsistent, for instance, when we do one thing and say another, and when this ambivalent state of mind is projected onto our relationships. When we are one with ourselves, there are no contradictions or conflicting elements within us that cause communicative ambiguity, uncertainty, and confusion.

In order for consistency to function as a means to concretize honesty, we need to be brave enough to become transparent and reveal our vulnerability, however miserable, worthless, guilty, or despicable we might feel. Vulnerability is a feature we all have in common, but one which most of us choose to hide or deny in various ways (unless we have adopted a victim role, which is based precisely on exposing one's vulnerability to receive the attention and special treatment of others). However, to build trust in relationships and be honest in terms of consistency, it is essential that we show ourselves precisely as we are, without the masks of goodness, toughness, authority, indifference, innocence or of being afflicted, tormented or whatever it may be.

Here we come to the second component of honesty on which the principle of truth is based, namely *authenticity*. Instead of being genuine and transparent, that is, honestly conveying our perceived ugliness, vulnerability, or our need for confirmation, we have a tendency to use communication as a tool to control the images that other people have of us. We struggle very hard to convey the image of ourselves or of various situations that we want others to have, and we cloak the

actions, thoughts and feelings that we are ashamed of and think are too ugly or ridiculous to put on display.

The problem is that when we conceal these aspects of us—when we do not communicate truthfully and transparently about them—we are no longer authentic but play different roles in our attempts to cover up what we do not want others to see. In addition to being untrue, the inauthentic is also very manipulative, because we seek to get what we want by appearing to be, for example, better and kinder than we genuinely feel; or, if we have taken on the role of the victim, innocent and in need of special attention and care. When all parties communicate like this in various contexts, what is communicated ultimately revolves around the images of ourselves that we want others to have, and the images that we have created of others involved. Such interactions obviously further underpin the experience of existential separation, and this is why inauthentic communication forms a very unstable and treacherous foundation for trusting relationships as well as a gigantic source of misunderstandings and conflicts.

Thus, being authentic means that we refrain not only from routinely adapting to what we think others want to hear but also from unreflectively communicating the images of ourselves that we want others to have. When we are authentic, we become transparent, because what we say is in alignment with what we do and what we think. We are one with ourselves and let our manipulative Janus faces go. We turn inwardly, become present, inhabit body and mind—accepting and embracing all thoughts and feelings. This paves the way for trust to build, regardless of whether we now appear less to our advantage than if we had taken refuge in our familiar roles, where we feel (relatively) safe and invulnerable.

Of course, in accordance with *Ahimsa*, we must be careful how we express these less desirable sides of ourselves and take responsibility for not harming other people. Perhaps we have to wait—sometimes for a very long time—before we know how to communicate consistency and authenticity in a compassionate, open-minded way.

## Observations and Emotions

Fortunately, there are tools available for the principles of consistency and authenticity to work not only in theory but also in everyday communicative practice. Rosenberg (2003) suggests, for example, that we communicate the truth, not about any objective reality (because this, as we have seen, is extremely difficult to assess), but the truth about our *observations* of this reality. We communicate what

we observe in a specific situation *without* evaluating the observation or drawing any conclusions from it.

At first it can be very difficult to distinguish observations that include an evaluation from those that do not, because we are used to quickly judging and evaluating what is happening around us. The communicative examples below seek to describe the difference. The first example illustrates a neutral observation without evaluative elements. It only describes the facts. The second example shows an observation that contains an evaluative interpretation through the generalizing word "always."

> You've been home late from work three times this week.
> You're always home late from work.

But how do we handle the feelings of discomfort that our thoughts about the observation trigger? Maybe we are genuinely worried about the late arrival home of the person in the example above. Well, if we stay in close contact with our innermost essence, we can more or less immediately neutralize these feelings, because in this place we are invulnerable to such experiences. However, for most people, this requires a lot of practice in the art of being present—allowing the almost automatic thoughts to travel to the peace within—and there is a considerable risk that we repress the disturbing feelings instead of eliminating them. Suppressed feelings are passed into dark corners within, where they linger and merge with previously repressed feelings (the pain body), and cause more and more discomfort of various kinds. To avoid this and to remain transparent in communication, we need to acknowledge the feeling, enter it, embrace it with compassion, and then—if necessary—allow it to take communicative expression.

Rosenberg (2003) suggests that based on the neutral observations we can express our feelings authentically without assigning another person responsibility for them. But in this context, he also emphasizes that we have to make sure that it is the *feeling* we are communicating. In English (as well as in Swedish) there is a significant tendency to express ourselves in emotional terms, when actually expressing an opinion or drawing a conclusion about the observation, that is, when we judge, interpret and evaluate what the observation means. In the example above with the person coming home late from work, this could be illustrated as follows. In the first example, a neutral observation and an authentic feeling are expressed. The second example illustrates an evaluative interpretation of the observation, rephrased and linguistically disguised as a feeling.

When you're home late from work three days in a week, I feel worried that you don't care about our family.

I feel that you care more about work than our family when you're always late.

Because language use to a large extent is automated and spontaneous, it takes a lot of practice to learn to identify authentic feelings. As a rule of thumb, Rosenberg suggests that when we express a feeling, we do not even need to use the word "feel." It can instead be replaced with the verb "be" in its various forms, for example, "I *am* jealous of his success" or "I *was* scared when you raised your voice." Compare this with "I feel he didn't deserve the success" or "I felt you were angry when you shouted at me."[19]

If we express in concrete and conscious language only what we observe in a particular situation and what discomfort the observation triggers, we avoid shifting responsibility for our distress to another person or to the external conditions. We always start with ourselves and recognize that the unpleasant reactions are the results of our own thoughts and stories about the situation. The focus is on the quality of the relationship, the desire for harmony and trust, and not on "getting" what we want by being communicatively clever—to get justice, or pity, or to attribute blame. We are authentic, transparent, and one with ourselves. And when we, in turn, are the recipients of someone else's authentic communication, we practice presence, listening, and open-mindedness, as suggested in the previous chapters.

## Unveiling the Ego

Since authenticity implies making yourself vulnerable, it may be difficult to open up to it by expressing true observations and feelings. But the fact remains: By exposing all the dark facets of the ego in the form of "forbidden" thoughts and feelings—accepting that they are there and surrendering to that fact—they can dissolve and disappear. The ego's thought is almost always accompanied by a negative feeling, which we can make use of and disclose to the person we are communicating with: "In this situation I feel scared." "When you say we're all one,

---

19 The expression "I am" is used here and in the next section for purely practical reasons as a tool to distinguish the authentic emotional expressions from the inauthentic ones. Who "I" really "am" lies beyond these concrete communicative situations and is best described with the expression itself. I Am. Nothing more (e.g., Spira, 2021).

I feel unsure." "I feel jealous when my neighbor buys new things for the house." In this manner, we can use the other person to illuminate the ego's oddities, and if we continue unveiling the ego to others instead of frantically trying to hide it through manipulative—inauthentic—communication, its power over us will gradually diminish. The Indian mystic Osho allegedly has expressed this process of authentic communication like this:

> Truthfulness means authenticity, to be true, not to be false, not to use masks. Whatsoever is your real face, show it…

The *Bible* expresses something like this too, albeit in slightly different (and probably frequently misinterpreted) wordings.

> Therefore, confess your sins to one another and pray for one another, that you may be healed… (James 5:16, ESV)

And Hammarskjöld (1964, p. 53) in his classic book *Markings*, synthesizes the message eloquently.

> Your fancy dress, the mask you put on with such care so as to appear to your best advantage was the wall between you and the sympathy you sought. A sympathy you won on the day when you stood there naked.

If, on the other hand, we try at all costs to hide the ego in the shadows, we energize it. In the darkness it thrives, grows stronger, and our refusal to acknowledge it makes us weaker and weaker. As long as we continue to convey the images of ourselves that we want others to have, our communication as well as our relationships remain inauthentic and conflict-ridden. We constantly reinforce the experience of loneliness and separation.

And if we think about it, would it really be so terrible to "stand there naked," in the words of Hammarskjöld? After all, it is only the changing personality, the roles, the specialness—the ego—that can be harmed by being unveiled, not our true Self. The moment we remember and return to our innermost true being, we notice that it is completely untouched and forever unchanged. And from this place, truthful communication pours forth.

# References

Buber, M. (2013). *I and Thou*. London: Bloomsbury Academic. (Original work published 1937)
Carlsson, O. (2014). *Just idag: 365 tankar för sinnesro* [*Thoughts for the day: 365 Reflections for peace of mind*]. Stockholm: Bonnier Fakta.
Easwaran, E. (2007a). Introduction. In *The Bhagavad Gita* (E. Easwaran, Trans., pp. 7–67). Tomales, CA: Nilgiri Press.
Hammarskjöld, D. (1964). *Markings* (L. Sjöberg & W. H. Auden, Trans.). New York: Knopf.
Lent, J. (2021). *The web of meaning: Integrating science and traditional wisdom to find our place in the universe*. Gabriola Island, Canada: New Society Publishers.
Lockie, S. (2017). Post-truth politics and the social sciences. *Environmental Sociology*, 3(1), 1–5.
Rosenberg, M. B. (2003). *Nonviolent communication: A language of life*. Encinitas, CA: PuddleDancer Press.
Spira, R. (2021). *A meditation on I am*. Oakland: New Harbinger.
Thich Nhat Hanh. (2013). *The art of communicating*. New York: HarperOne.
Wilber, K. (2000). *Integral psychology: Consciousness, spirit, psychology, therapy*. Boston & London: Shambala Publications.

# 8

# Joy

In the midst of winter, I found there was, within me, an invincible summer. And that makes me happy. For it says that no matter how hard the world pushes against me, within me, there's something stronger—something better, pushing right back.[20]

This chapter addresses the importance of joy for communication to become an effective tool for (re)gaining what is rightfully ours, namely trust in each other and the experience of interconnectedness. I am, however, not convinced that joy is the best word in this context, because what I am referring to is not an exhilarating happiness but rather something like deep peace and contentment. Rupert Spira has illustratively described joy, or happiness, as "peace in motion," which gives a much better picture of what it means. I would also like to add the word "freedom" to that description; a sparkling sensation of being completely boundless.

Joy, happiness, and freedom are constantly available within us, just as the introductory quote illustrates, and when we are in touch with the essence of our innermost being we can look at everyday life with new and grateful eyes. When we log into the eternal Now and stop projecting labels and values, even the smallest of experiences obtain a wholly new dimension and a joyful meaning. And when we communicate from this place, we can spread nothing but joy around us. Thus, we need not wait for the big events in life to bring us temporary happiness, but instead discover the joy—the summer—that is always available within.

20 Quote commonly attributed to Albert Camus.

Joy wants to be extended to others, so that it may spread from relationship to relationship.

Whining and complaining is something we humans often indulge in, and this effectively prevents us from experiencing joy. We complain about the weather, our boss, colleagues, partner, the government, and we do this without really reflecting on this communicative pattern. At least in some cultural contexts, it is rather the rule than the exception that people's relationships—in the family, at work, in their spare time—are predominantly based on such negatively charged communication. But if communication is to scale up trust and harmony between people and scale down separation, we should not abuse its potential by complaining. Regardless of whether the topic seems trivial, such as the weather being bad, any complaint, even those that appear to nurture relationships (which is a major function of communication), carries a negativity that produces disharmony within and without. Any type of complaint also makes us victims of the circumstances and maintains separation by obscuring that all that *is* (even the boss!) is part of the seamless whole to which we all belong. When we charge something in this universal totality with negative energy, this negativity relentlessly comes boomeranging back at us. Remember the enormously creative power of thoughts and language and how they shape, even cause, the reality we experience.

In the *Bhagavad Gita* (18:36–39), three forms of happiness and joy are described. The first and, according to the Gita, only true form of joy is born from a peaceful and intensely present inner, which the summer metaphor in the opening quote corresponds to. Here, duality is transcended, and no opposite exists, which means that happiness is not dependent on an oppositional phenomenon such as misery or hardship but constitutes the natural state. The second form of joy that the Gita presents comes from "outside" and as such is constituted by duality, which means that what is experienced as pleasant at the beginning is gradually transformed into something unattractive or uninteresting. This kind of joy is thus temporary and new external stimuli are required for joy to gain new but sadly transitory power. The third and lowest form of joy derives, according to the Gita, from the pleasure of the senses. It is obtained through sleeping, indolence and/or use of drugs (nicotine, narcotics, alcohol, food, etc.), which in various ways aim to reduce discomfort of different kinds and intensity. This form of happiness is altogether illusory and has nothing to do with genuine experiences of joy.

The various forms of joy expressed in the *Bhagavad Gita* carry significant similarities with the view of Aristotle in ancient Greece. Aristotle divided happiness

into two categories, *eudaimonia* and *hedonia*, where the former to a large extent corresponds with the first form in the Gita, that is, a lasting state of contentment that arises from fulfilling one's true nature. The latter is a short-lived type of joy resulting from external stimuli and the pleasure of the senses, just like the Gita's second and third forms. Lent (2021, p. 220) suggests that as a society, our manic drive for hedonic moments has come at the expense of eudaimonia.

The view of happiness expressed in the *Bhagavad Gita* and by the Aristotelian perspective undoubtedly prompts questions whether it is possible to actually experience such lasting joy as described in the first form of the Gita and by the concept of eudaimonia. Is not happiness something you can only experience very briefly, in connection with certain activities? Is not happiness by definition something temporary? Well, in our dualistic and materialistic society, the notion of the rare and ephemeral happiness is internalized into our worldview as something natural. If, as children, we had the privilege of experiencing joy and even believed that it belonged to us, adulthood quite quickly put an end to that delusion. As adults, we are expected to be content with brief moments of happiness and to even defend the idea that we need, if not unhappiness, at least boredom or periods of suffering to identify it at all. The dualistic understanding that we need something to contrast happiness with has been naturalized and reached a position beyond questioning.

And it is true that if we seek happiness through the body, the mind or the world, the moments of joy are few and short—completely in line with the Gita's second and third form of joy as well as the Aristotelian concept of hedonia. As soon as we achieve our materialistic, ego-driven goal we immediately aspire to the next step, never satisfying our need for more (Lent, 2021, p. 220). If we lose our foundation in the quiet, open Now—the expanse within—and instead allow ourselves to be drawn into and identify with external objects, the internal joy is obscured by the multitude of external stimuli. Through these we can certainly obtain momentary pleasure, but lasting joy and happiness come from within, and it is also from there that we can continuously communicate and extend authentic, joyful trust.

> The joy of this state cannot be described. This is *Ananda:* pure, limitless, unconditioned joy. The individual personality dissolves like salt in a sea of joy, merges in it like a river, rejoices like a fish in an ocean of bliss. (Easwaran, 2007, p. 40)

Our human nature means that we experience a wide range of feelings on a daily basis (even if this varies between individuals), and there are moments when our

life situation pulls the rug out from under our feet; we lose someone we love, we or someone close to us become seriously ill, we lose our job, or the like. In such cases, of course, we are not supposed to walk around pretending to be happy. If we feel, for example, grief, we have to live through the grieving process in utmost compassion for ourselves. Chapter 3 emphasized the importance of not repressing but, in complete acceptance, let the light of awareness shine on hurtful feelings, so they may dissolve by their own intensity. Maybe we also need to change or leave destructive situations and relationships before joy can take its rightful place in our life situation. But the truth is that we also (and perhaps primarily) in the mundane life of the everyday effectively erect obstacles to the joyful state—*Ananda*, the summer within—through a problem-oriented thought pattern and negatively charged communication. The next section deals with that.

## Disarming the Ego with Humor

In order to let ourselves experience and communicate the joy that is inherent to our being, it is necessary to identify who or what it is within us that instead wants to focus on problems, on conflictual situations and relationships. Is it really our entwined, true Self? Our innermost being? No, the one who loves to identify and even invent threats and problems for the mind to struggle with is the ego. This separate and special self-construction—whether smaller, bigger, better, or worse than others—feeds on contrasting itself with situations and people. But when the ego grabs hold on certain threats and problems, they immediately become constitutive of what we perceive as reality. Our experience will be characterized by discomfort, anger, sadness or pure pain; feelings that most often come to communicative expression in the form of complaint, attack, defense, and polarization. What we think and feel inside is reflected on the outside.

But do we have to let the more or less constantly threatened and conflict-seeking ego take charge? No, the next time we experience ourselves provoked in a communicative situation, let us instead practice discernment; who is it that thinks it is threatened? Is it not the ego that believes it is attacked by another ego or a polarized situation? When we discern the ego as the creator of our state of mind, we can more easily manage the situation through loving authentic speech and deep listening. We remind ourselves that we do not have the whole picture that constitutes the context of the situation. What we are upset about are only fragments of a whole that consists of the past as well as the future for several people involved. We probably do not even have the whole picture of the present

moment on which to base our agitation. So, we remain humble and keep an open mind to the fact that we do not have all the information necessary to make a valid assessment of the situation.

When we allow the agitated mind to sink into the boundless heart and the deep roots of presence to take hold within us, we are connecting with the true and joyful Self. When we let go of prestige, which belongs to the ego's domains, and view the situation with detachment, we can instead disarm the budding conflict with humor. We can simply stop taking ourselves so incredibly seriously and twist and turn the communicative situation to find an opening for liberating laughter. We do not strive to be clever in communication or to reach any specific goal, but our ambition is to be creative and have fun, because humor is an unmatched way with which to cope with the ego. In the bigger perspective, things that appear to be outrageous may actually contain elements of comicality, just as Charlie Chaplin allegedly expressed it in a witty analogy to the film world: "Life is a tragedy when seen in close-up, but a comedy in long-shot."

So, let us take a step back and allow ourselves to laugh at the agitated thoughts of the ego and recall that this troubled person with whom we identified for a moment is not what we *are*. The ego is just a changing process of thoughts, values, feelings, and experiences, but in our innermost being we are pure joy and happiness no matter what happens on the surface.

## Choosing Joy

> Ultimately, I would rather be free and in love than be right.[21]

In every situation we have the freedom to choose our state of mind as well as our way of communicating. In chapter 6, it was described how every form of attack—from the slightest irritation to full-blown outrage—fuels the experience of separation and works against trusting relationships. Attack is also the direct opposite of joy. This means that every time we yield to sulking or (heated) argumentation in order to prove—at all costs—that we are right, we are effectively preventing the inherent joy from manifesting communicatively. Thus, when you feel the desire to argue or being grumpy escalating, you might want to ask yourself the question of the opening quote: Would you rather be free and in love or be right? Because you cannot have them both.

---

21   Quote commonly attributed to Ram Dass.

The most important—or indeed the only—key to lasting happiness is forgiveness, which was described in chapter 6. We forgive broken aspects within ourselves so that the power of joy within us has a free outlet. We refrain from attributing blame to others, and we choose open-mindedly to shift our perspective to seeing our fellow human being as without guilt, completely equal and part of the totality. Admittedly, the more or less automated attributions of guilt can be difficult to neutralize before they take shape, but it is enough that we notice them and set them aside instead of acting upon them. Sympathies and antipathies might be there, but we need not be slaves to them. Remember that people's seemingly destructive communication is rooted in unconsciousness and not in the essence of who they really are. Look beyond the appearance and forgive the illusory reality that leads us to focus on what seems to separate and obscures what is absolutely true, eternal, and unchanging: the shared essence of all.

It is only through forgiveness that we can be happy, because how could we be happy when carrying "a bunch of chairs and tables on a rope around our neck," as the young man in chapter 6 put it? In fact, forgiveness and happiness are one hundred percent inseparable, because what we give is what we get. If we do not forgive, we do not get lasting happiness, joy, and peace of mind. The good news in all of this is that we can always choose forgiveness in thought and communication instead of attack—in all situations, everywhere and all the time. And when making this choice, we also choose joy over discomfort and pain for ourselves. So, in the challenging communicative situation, where we almost obsessively want to argue, attack, defend, or perhaps sulk in silence, we remember the simple words "Let me forgive and be happy" and expect—even intentionally evoke—the feeling of joy.

Almost all emotional discomfort that stands in the way of joy, is due to our own resistance; that we refuse to accept the present moment as it is, and instead regard the communicative situation as imperfect or undesirable. Therefore, the next chapter addresses the principle of acceptance.

# References

Easwaran, E. (2007). Introduction. In *The Upanishads* (E. Easwaran, Trans., pp. 13–47). Tomales, CA: Nilgiri Press.

Lent, J. (2021). *The web of meaning: Integrating science and traditional wisdom to find our place in the universe*. Gabriola Island, Canada: New Society Publishers.

# 9

# Acceptance

> Happiness is simply to allow everything to be exactly as it is from moment to moment.[22]

Almost all the ethical principles presented here have mentioned "acceptance" as an important ingredient, and this chapter delves deeper into its meaning. I have intentionally let the principles of presence and acceptance enclose the other seven principles, because they are necessary conditions for the remaining principles not to stay only theoretical constructions. Communication for scaling up trust and scaling down separation must, of course, be lived and not only theorized, and without presence and acceptance, the other principles are not very effective in practice. Presence and acceptance are also intimately interlinked—no presence without acceptance and no acceptance without presence.

## Surrendering to What Is

As the opening quote suggests, acceptance is about allowing whatever comes into the attention field; (communicative) events, sensory impressions, situations, thoughts, physical sensations, and feelings. It is a matter of observing and acknowledging these forms *but* refraining from logging into and identifying with

---

22 Quotation commonly attributed to Rupert Spira.

them. In this way, we are no longer at odds with our experience, and this sense of alignment with life brings forth peace and stability (Adyashanti, 2013). Because as soon as we resort to resistance and to the thought "I want out of here!" we add fuel to the experience of separation which prevents us from experiencing All as One and from communicating trust.

Importantly, accepting what happens at a given moment does not mean that we have to agree with what other people say or do. No, it is about accepting that this is what is happening right now, at this very moment, however we might feel about it. End of discussion. Like this, we prevent the immediate thoughts and emotional reactions from taking control over what and how we communicate. Instead, we stay present, in touch with the breath and the deep, formless Self. Acceptance and the absence of resistance is in fact innate states of the eternal Now and if the situation needs to change, the answer from this place will be much wiser than anything we can cognitively imagine.

Letting go of resistance and surrendering to the "isness" of the situation, should therefore not be understood as giving up, only as giving in—letting go. And it does not necessarily mean staying passive either; it is quite possible to act if the intuitive wisdom within guides us in that direction. We can easily distinguish between the initiative prompted by this wisdom and that of the ego by observing our state of mind. The ego is always agitated in some way—angry, disappointed, irritated, disappointed, frustrated—and resists what is, while the deep Self is characterized by pure peace or peace in motion. The sacred outrage described in chapter 6 is the only exception to this.

However, when we stay in contact with our innermost being, we surprisingly often discover that there is no need to interfere with the situation at all. We might quite simply let things be as they are, while still maintaining peace of mind. In Taoist philosophy, the term *Wu wei*[23] refers to this as a kind of effortless action, which is believed to be the best method to stay on the Way (*Tao*), that is, to remain in the absolute Truth. *Tao* "acts without action, does without doing" (*Tao Te Ching*, ch. 63), and *Wu wei* is thus not regarded as something passive, but as the most efficient type of action. It requires conscious attention as well as integration with the deep Self and the flow of the present moment and should not be conflated with acting spontaneously on our emotions or simply being lazy (Lent, 2021). In popular culture, the Beatle's tune *Let it be* is perhaps the most

---

23 The opposite of *wu wei* is *yu wei*, goal orientation—a defining and seldom questioned virtue of modern society as noted in chapter 1.

illuminating example of such surrendering of control and agitation, letting the struggle be.

The key to happiness and harmonious, trusting relationships thus lies in the ability to surrender to what is—right here and right now. To just rest and allow ourselves to remain in the quiet expanse within. To accept any pain and embrace it with our warmest and deepest compassion (but without assuming the role of victim). If we nevertheless feel resistance growing within, we surrender to this as well to avoid reproducing the vicious circle by resisting the resistance. We have no expectations whatsoever of how we *really* should feel but allow all discomfort to come forth, witnessing but not identifying with it. The person who releases all resistance—"runs not after the pleasant or away from the painful, grieves not, lusts not, but lets things come and go as they happen," as described in the *Bhagavad Gita* (12:17).

In the act of surrendering, we also become comfortable with the fact that we do not know what situations, things, and people really are like. We keep an open mind in acceptance of our own ignorance.

## Merrily, Merrily, Merrily …

Obviously, the communicative practices must also comply to the fundamental principle of acceptance if we want to find (or rather remember) the trust that the interconnectedness of all things guarantees. Everything in the world of form changes in cyclical patterns and communication has to follow this dynamic as well. This is, of course, easier said than done when we are confronted with the turmoil of the world, and a few mental tools may be helpful for maintaining presence and adapting to the constant movement of the flow of communication. The detachment that *Wu wei* requires is exemplified below with the visual parable of the stream and how the water intuitively evades the massive rocks in its path (cf. Tolle, 2011).

So, in a challenging communicative situation, where cognitive and emotional resistance are building, you may visualize how a rippling stream suddenly encounter a massive rock in its path. Imagine that you are the flowing water, and the rock is the communicative challenge. Like the water, you do not resist the rock in fruitless attempts to dislodge it, instead you naturally and effortlessly find alternative ways to unaffected ripple past the solid mass. Should the water resist the rock, very soon its energy would stagnate, and its freshness be replaced by mud. Because as soon as you clash with the communicative challenge, form

attack thoughts in your mind and attack feelings stir your body, the separation is reborn. Both you and the other person will suffer when the communicative flow becomes clogged and opaque. Wisely, you then recall the lyrics of the children's song: "Row, row, row your boat, gently down the stream. Merrily, merrily, merrily, merrily, life is but a dream …," and ease up.

We may also use forgiveness, as described earlier, to avoid the communicative collision, thus making an effort to shift perspective and to see the situation differently. This way, we may perceive the truth about ourselves and the other person, that is, that we in our essence are not two-pieced and polarized beings but unified in One. And we forgive ourselves, our pain body that triggers the negative reactions and turns the Now into a repetition of the past (Tolle, 2011). We remember that what we give is what we get, and that acceptance of ourselves, other people, and the world as a whole is a prerequisite for compassion and lasting joy and happiness.

All resisting, judging, analyzing, naming, and projecting—indeed, all struggling—sooner or later leads if not to exhaustion at least to considerable fatigue. The peace that is offered when we allow the accepting Now to take root within is soothing balm for the soul. Thich Nhat Hanh (2013) says that by accepting the moment just as it is, we follow the path home. The Christian *Serenity Prayer*[24] comes in handy as an illustration of this.

> God, grant me the serenity
> to accept the things I cannot change,
> Courage to change the
> things I can, and the
> wisdom to know the difference.
> Living one day at a time;
> Enjoying one moment at a time;
> Accepting hardship as the pathway to peace.
> Taking, as He did,
> This sinful world as it is,
> Not as I would have it…

If you feel resistance to the prayer's terminology—the words "God" and "He"—and find it difficult to let it go, you can modify the meaning according to your own understanding of the universal force. Perhaps you will find the suggestion of this book useful, that is, that you come into contact with this "higher" power

---

24  Serenity prayer commonly attributed to Reinhold Neibuhr.

in the deep space within yourself, in the interconnection of all that *is* in the indivisible seamless whole.

# References

Adyashanti. (2013). *Falling into grace: Insights on the end of suffering.* Boulder: Sounds True Inc.

Lent, J. (2021). *The web of meaning: Integrating science and traditional wisdom to find our place in the universe.* Gabriola Island, Canada: New Society Publishers.

Thich Naht Hahn. (2013). *The art of communicating.* New York: HarperOne.

Tolle, E. (2011). *The power of now: A guide to spiritual enlightenment.* London: Hodder & Stoughton.

# 10

# Sustainable Communication and Deep Sustainability

> Understand with your mind and feel with your heart that everyone and everything is an expression of a single infinite and indivisible whole, and act accordingly. If we did that, there would be no conflicts, no war, no environmental problems. That's all that's necessary.[25]

In this concluding chapter, the suggested communication ethics will be synthesized and conceptualized as *sustainable communication*. This means that we will leave the level of the individual and instead address the unsustainable situation the world is facing; climate change, biodiversity loss, acidification of the oceans, and military conflicts, just to mention a few of our many mega-problems of global scale. The discussion that follows should not be seen as exhaustive, but rather as reflections on the need for the expansion of consciousness to the point where we can see beyond the effects of *maya* and gain access to a higher level of reality—the interconnectedness of everything. The most adequate label for this transformation is perhaps that of a paradigm shift; a transformation to a more advanced level of consciousness, which would lead to a renewed view of the world.

> At our current trajectory, humanity is headed for catastrophe. But it doesn't have to be that way. If we want to steer our civilization on another course, though, it's not enough to make a few incremental improvements here and there. We need to take a long hard look at the faulty ideas that have brought us to this place and

---

25 Quote commonly attributed to Rupert Spira.

reimagine them. We need a new worldview—one that is based on sturdy foundations. (Lent, 2021, p. 4)

In this transformational process, the proposed communication ethics contributes to a sustainable communication that helps us overcome the world of opposites and grants us access to an authentic experience of the indivisible whole.

The chapter closes by elaborating on sustainable communication in terms of love—the single path to a deeply sustainable world.

## Deep Sustainability

This may sound strange coming from a person with such a strong foundation in science as myself, but I would suggest that we do not need much more scientific knowledge to deal with the grave sustainability challenges ahead. What we need is a recognition and an acknowledgment of the intuitive wisdom, so that we can make good use of the knowledge that already exists. The core of this wisdom consists not only, or even primarily, of an intellectual insight that everything is One and interwoven into a seamless whole but involves, above all, a profound and transforming *experience* of this absolute Truth; that the essence of ourselves, our innermost being, is the essence of *all* beings. What is implied here is thus not of the theoretical or metaphorical kind but is, in the words of ancient Indian wisdom, constituted by *darshana*, that is, "something seen" (Easwaran, 2007, p. 23).

When we are deeply rooted in such an experience, it becomes—just as the quote that introduces this chapter suggests—impossible to behave in irresponsible and unsustainable ways toward human and non-human nature. The profound realization that what we do to other human or non-human lifeforms we do also to ourselves comes with very concrete consequences. When the intuitive wisdom leads us into an experience of being part of the totality, we quite naturally adjust to and trust it. They who see themselves in everything and everyone, is not capable of doing harm, since there is no "other" to distrust. Everything that exists is I in extended form.

> Those who possess this wisdom have equal regard for all. They see the same Self in a spiritual aspirant and an outcast, in an elephant, a cow, and a dog. Such people have mastered life. (The *Bhagavad Gita* 5:18–21)

I would argue that the realization of oneness is not an optional ethical-spiritual endeavor but in fact *required* for what could be labeled "deep" sustainability. This

concept has developed as an extension of the concept of deep ecology (Cronon, 1996; Macy & Kazy, 2021; Naess, 2016) and builds on the idea that lasting and authentic sustainability involves the development of a new and different view of the relationship between humans and other lifeforms (e.g., Buriti, 2019; Martin, 2020). This view would include scholarly perspectives from, for example, ecospirituality (e.g., Singh, 2017), ecofeminism (e.g., Adams & Gruen, 2014), and critical animal studies (e.g., Kemmerer, 2014) as well as questions about animal rights (e.g., Freeman, 2020) and earth rights (e.g., Hultman et al., 2022). To obtain deep sustainability, an integrated ethical system that acknowledges life as one (such as the ethics proposed in this book) is needed.

But what does the current relationship between humanity and other lifeforms look like, then? Based on my research interest in environmental communication, I sometimes ask my students from different parts of the world to explain the nature of nature. These students have a special interest in sustainability, and it would be reasonable to expect that they, if any, would have a rather advanced understanding of nature. Almost without exception they answer: "Nature is wilderness. Places that are untouched by humans." Maybe your answer would be similar? If so, you are certainly not alone. Studies have shown that this is a widespread taken-for-granted assumption (Olausson, 2020). Nature is where humans are not.

Unfortunately, this naturalized assumption does not facilitate the experience of the indivisible whole in which everything is interconnected.[26] The notion that humanity is external to nature is reproduced through a dualistic and naturalized language, where we spontaneously separate nature from society and animals from humans. The reproduction of this dualism applies not least to the scientific institution, where the natural and social sciences as distinct and rather diverse disciplines rarely come into communicative contact with each other. But for deep sustainability, filling the breach between nature and society is essential, because it is this duality that ultimately legitimizes the continuous exploitation of non-human lifeforms (Abram, 1997). If nature is not included in our in-group identity, there is no obvious reason to protect it.

When it comes to global sustainability in general, there is today a relatively lively and definitely much-needed discussion regarding its environmental, social,

---

26 It is also based on an incorrect idea of what we perceive as reality; in the Anthropocene (a debated term that refers to the epoch after the Holocene), humanity has in one way or another affected all parts of the natural environment. Hence, there is no "pristine" nature.

and economic dimensions, and—to a certain extent—their interrelations. The UN's Agenda 2030 with its 17 sustainability goals (SDGs) is a telling example of this. Unfortunately, the whole discussion largely lacks the important role of communication (Berglez, Olausson, & Ots, 2017), and has a strongly anthropocentric bias. The latter means that attention revolves around human needs, and that it is for the sake of the well-being of humanity that environmental sustainability must be established; nature itself is not ascribed any inherent value. In this way, humanity is depicted as superior to nature and human needs as the single incentive for sustainability work, all of which strengthen the nature-culture dualism identified in several studies (Cronon, 1996; Olausson, 2020; Uggla & Olausson, 2013).

A similar critique (e.g., Kopnina, 2019; Martin, 2020) has been aimed at the SDGs because of their alleged instrumental use of nature, for example to eradicate poverty and combat climate change. Critiques also claim that the goals generally prioritize the economy instead of the planet, even though the latter feeds both the social and the economic systems. The conservation movement, which works for the legitimate purpose of preserving various animal and plant species, also has a largely anthropocentric profile where human needs determine the value of nature (Olausson & Uggla, 2021). The nature-culture dualism thus prevails regardless of whether the argument is to preserve nature or to exploit it (Pollan, 1991). To continue further down this road, that is, to separate humanity from nature, and to let nature remain a tool for economic development through "eco-system services" and the like, is not the answer to the sustainability crisis. In the words of Lent (2021, p. 271), "at the deepest level, we must ask what kind of ludicrous folly it is to debase our living Earth, the only source of life that we know of in the universe, to a financial market instrument."

Pattberg (2007) describes how all the notions associated with the human-nature dualism together form an "ideology of dominance," which underpins and legitimizes the exploitation and destruction of land, sea and non-human lifeforms that today have reached devastatingly high levels. As Lent (2021) points out, once the scientific revolution took off in the seventeenth century, ideas about the Earth as a living organism (Gaia), were harshly refuted. Along with this development, nature increasingly became a thing for humans to master, control and dominate, and such practices obviously require a prevailing understanding of humanity as something completely different from and superior to all other lifeforms.

> For, of course, to speak of man [sic] intervening in natural processes is to suppose that he might find it possible not to do so, or to decide not to do so. Nature has

to be thought of … as separate from man, before any question of intervention or command … can arise. (Williams, 2005, p. 76)

But the anthropocentric figure of thought and language, in which everything revolves around humanity, is unsustainable in the long run. Although we are inexorably woven into the ecological systems and imbalances in them jeopardize our existence, we must also recognize and respect non-human nature as a world with its own, non-human reasons for being as it is (Cronon, 1996; Naess, 2016). Such a biocentric perspective, where humanity becomes just a facet in a more-than-human world (Abrams, 1997) is necessary for the human-nature dualism to wither in favor of an experience of intimate connection with all lifeforms.

Several modern spiritual-philosophical truth-seekers have suggested that this is the only way we can establish long-term solutions to the sustainability problems. If we do not shift attention to the indivisible whole—to the interconnectedness of all life—but continue to ignore this absolute Truth, the global problems we are facing cannot be solved for good. We can alleviate the symptoms and find temporary technological solutions, but as long as we keep living with separation, polarization and conflict in our minds, seeing ourselves as superior to everything else, this inner state will keep manifesting as chaos in the exterior. New and even more harmful problems quickly appear around the corner.

Wilber (2000) describes the same thing from the perspective of developmental psychology.[27] He outlines the different developmental stages of both individual and collective consciousness, which comprise two levels—one lower and one higher (Table 10.1).

Table 10.1. The Evolution of Consciousness (Adapted from Wilber, 2000, pp. 48–53)

| Step | Level 1, characteristics | Level 2, characteristics |
|---|---|---|
| 1 | Instinct. Survival. No distinct self. Collectives formed for survival. | |
| 2 | Magic. Animistic thinking. Kinship and heritage. Ethnically formed tribes. | |

27 Wilber is here inspired by Clare Graves's "spiral dynamics of existence."

| Step | Level 1, characteristics | Level 2, characteristics |
| --- | --- | --- |
| 3 | Egocentric, heroic self. Feudal empires. Power and honour. | |
| 4 | Sociocentric self, conformist to a pre-defined social order. Rigid social hierarchies. Dualistic and loyal to principles (e.g. right–wrong, good–evil). Ethnocentrism and nationalism. The nation. | |
| 5 | Individualism and scientific worldview. Nature obeys laws that can be manipulated. Material gain in focus. United states. | |
| 6 | Sensitive, relational, and global self. Ecologically conscious. Non-hierarchical. Focus on dialogue and relations. Pluralistic relativism. Multiculturalism. Voluntary communities. | |
| 7 | | Integral transpersonal self. Nondual. Flexibility, spontaneity, functionality. Knowledge and competence superior to status, power, and social position. |
| 8 | | Universal holistic system. The self integrates and accepts all previous developmental stages. Nondual. Perfect unity possible. |

The first and lower level contains six stages and ranges from instinctive consciousness, where the survival of the body is superior to the development of self, to global consciousness, where care for the earth and the more-than-human world characterizes the self. Thus, at this level, consciousness expands from the instinctive to the egocentric to eventually become sociocentric, for example, in the form

of ethnocentrism and nationalism. The development of consciousness continues into the form of scientific rationality and culminates in the inclusive and pluralistic global self. These steps are not mutually exclusive but the individual or the collective oscillate between them depending on context.

The second and higher level of Wilber's model involves a radical shift in consciousness, when the still separated self transforms into a transpersonal, nondual "being." The last of the two steps at this level consists of a cosmically integrated system, in which all previous developmental stages are accepted. Through this step, perfect union in the one consciousness emerges. Wilber argues that lasting solutions to the sustainability problems (which would produce deep sustainability) in fact require the evolution of this second level of consciousness. This implies nothing less than a paradigmatic shift in worldview, the set of taken-for-granted values and beliefs that constitutes the "operating system" of human culture (Lent, 2021).

Crucial to the social dimension of sustainability is the quest for a vibrant and inclusive democracy. Political philosopher Mouffe (2005) argues, for example, that communication is inevitably imbued with power relations. Communicative conflicts are therefore characteristic of a well-functioning democracy, because at the very moment when consensus seems to have been reached, there is always some, less resourceful, identity group that has been oppressed.

Mouffe's conflict perspective on democracy is entirely valid, while the greater part of humanity remains at the first level of consciousness in Wilber's model, characterized by separate selves. At this level, differentiation toward the "others" seems to be necessary in order to shape and establish one's in-group, which also shifts depending on context (Olausson, 2005). Consequently, according to Wilber (2000), individuals and collectives on the various developmental stages at the first level are in constant conflict with each other in their struggle for dominance. Today, we can see evident examples of this not least in public discourse; fundamentalism of various kinds, including dogmatic nationalism, where duality is strongly rooted in principles of right and wrong (step 4 in Wilber's model) stands in stark polarity to pluralist relativism (step 6 in Wilber's model) and vice versa.

The identity positioning at the first level of consciousness means that if you identify only with yourself, your communication with others will be narcissistic and selfish. If you identify with your nation, you will communicate with your fellow countrymen/-women (possibly with those of "correct" ethnic origin) as fellow human beings. If you identify with all people, you will treat and communicate with and about all people fairly and with compassion. If your identity extends

to the more-than-human world, you will treat all sentient beings with respect and kindness. You then begin to realize, and above all experience, that all are perfect manifestations of the same web of life as you. It is at this stage you begin to understand and are able to communicate from your essential identity, which is not dependent on the definition of an out-group, namely the boundless Self. The goal must be to communicate from such an extended identity position since we will treat other beings well insofar as we identify with them. This last identity step thus implies a radical transformation to the second level of consciousness in Wilber's model.

Wilber (2000, p. 53) emphasizes that if humanity does not want to remain victim of a global "autoimmune disease," the shift to the second level of consciousness—the transpersonal—is required. Both the social and the environmental sustainability problems are due to the fact that not enough people have moved toward the higher developmental stages and the second level of consciousness. Once there, caring for the more-than-human world becomes natural.

> The ecological crisis—or Gaia's main problem—is not pollution, toxic dumping, ozone depletion, or any such. Gaia's main problem is that not enough human beings have developed to the postconventional, worldcentric, global levels of consciousness, wherein they will automatically be moved to care for the global commons. (Wilber, 2000, p. 137)

Abram, in his book *The Spell of the Sensuous* (1997), even proposes that the ongoing destruction of non-human environments and the extinction of non-human lifeforms are also the cause of the disunion, disharmony and lack of trust in human relationships. Obviously, in an interconnected—quantum entangled—existence, what is done to others is done also to ourselves.

> When I understand that my very existence at its core is part of the existence of each ecosystem and species around the world, then I know that whatever happens to them is in a way happening to me. (Eisenstein, 2022)

In sum, if the separation between humans and nature is a delusion made up of a tyrannical (and ideological) structure of thought and language, which obscures the unity of all life, it is quite reasonable to assume that the cruelties that humans inflict on non-human nature have destructive effects also beyond themselves. This adds to the relevance of acknowledging and addressing the tyrannical communicative-cognitive structure of duality as an essential cause of the grave

sustainability challenges of today. Doing so would mean to overcome the world of opposites and to set the stage for deep sustainability to evolve.

## Communication Beyond Language

If we truly want to move toward deep sustainability and the expansion of consciousness, it is extremely helpful to deeply reconnect to non-human lifeforms, to the more-than-human world, or to what we in everyday speech call nature. All aspects of nature carry the potential of unveiling the absolute Truth, that is, that everything is One. When we approach nature wordlessly, without analyzing or naming but with minds and hearts wide open, the way is paved for a spontaneous pre-conceptual experience of being part of it all. Such direct experience of non-human life forms is something completely different from intellectual knowledge about them.

By means of the sociolinguistic tradition of semiotics, one of the previous chapters highlighted that all language is symbolic only. No matter if the word is spoken, written or the sign is visual, in communication we are dealing with mere re-presentations of something else. This implies that the meanings the signs are intended to symbolize are not given but vary greatly between individuals and collectives as well as between historical and cultural contexts. And if we really think about it, the name of an object—its symbol, its sign—tells us nothing about its properties, forms or expressions. Yet, we believe that we have learned something about a bird, a mushroom, or a tree, when we have learned its name, and that this is what constitutes "knowledge." As Dickinson (2013) states, most people collect names instead of experiences of other lifeforms. But by refraining from naming, by not defining an object with a specific linguistic sign, we open ourselves to a transcendent experience of closeness and union. The intertwining of all life becomes obvious, when we are completely immersed in the immediate sensory perceptions and stay in close contact with the source of our being (Abram, 1997).

In the research field of environmental communication, studies have shown that the absence of human communication and naming is crucial for the experience of connection with nature. Such an experience has therefore been called an "expressive but unnamable coexistence with nature" (Carbaugh & Boromisza-Habashi, 2011, p. 114). Milstein (2008) argues that our attempts to verbally convey such deeply meaningful "humanature" experiences actually become a verbal "encapsulation" of the experience, and that this leads to a separation from the nature aspect we are trying to conceptualize. Thus, a genuine experience of the

unification of all life cannot be captured with the crude communication tools we have access to through language. This also becomes apparent in Abram's (1997, p. 21) own attempt to put his "expressive coexistence" with various nature aspects into words:

> It was as if my body in its actions was suddenly being motivated by a wisdom older than my thinking mind, as though it was held and moved by a logos, deeper than words, spoken by the Other's body, the trees, and the stony ground on which we stood.

As the quote above indicates, he does not fully manage to convey his unified and direct experience without the objectification of an "other," and Abram also admits that the more he talks about non-human beings, the less he is able to communicate with them.

When we try to convey experiences of "interbeing"—oneness—communicatively, the effect is often the opposite, namely a reproduction of separation. The inadequacy of words is with clarity expressed in the *Tao Te Ching*, which asserts that "the Sage speaks very little, for words embody conceptual distinctions and so lead us further from the Tao." (Wilkinson, 1997, p. xiv). However, the grave limitation that duality constitutes is not universal but typical of the language communities in the industrialized parts of the world. It is mainly here that the experiencer linguistically is separated from the experienced, the external world from the internal, and the organism from the environment (Milstein, 2008). In a study of indigenous peoples' relationship with nature, Valladolid and Apffel-Marglin (2001) identify a conversation of the senses between all aspects of nature. This conversation is neither literal (linguistic) nor metaphorical (conceptual) but rather mutually real and completely non-anthropocentric, that is, it does not revolve around human communication.

Again, it can be concluded that the absolute Truth cannot be communicated in ways we are used to. It can only be perceived, experienced, and so communicated in silence—through our pre-conceptual identity.

> Whenever I quiet the persistent chatter of words within my head, I find this silent or wordless dance always going on—this improvised duet between my animal body and the fluid, breathing landscape that it inhabits. (Abram, 1997, p. 53)

There are, thus, no words that are suitable for describing the transcendent moments, when the duality between the perceiving subject (human) and the perceived object (nature) collapses. The moment we experience that "both the

perceiving being and the perceived being are *of the same stuff*" (Abram, 1997, p. 67, italics in original), there is a shift in consciousness toward a nondual reality found beyond words. This completely unified state of pure merging and perfect extension of the Self is, however, difficult to maintain. But when we practice it again and again—preferably in meditative connection with non-human nature—full certainty of the oneness of all life will form a quiet background of safety, trust, joy, and timelessness behind even the most challenging moments of everyday life.

If we fully accept the ontological premise of the communication ethics proposed here, that is, that everyone's seemingly separate selves in their essence are One, then this kind of communication-beyond-language applies not only to our interaction with other lifeforms but also to our communication with human beings. It may sound like science fiction, but the fact that we can engage in transcendent communication, which only takes place on the inside, has long been considered probable by philosophers, spiritual teachers, artists, and writers. It is thus not only the advanced lifeform Kollos in the Star Trek epigraph of this book, who implies that there are other modes of communication than the sign-based language we are used to. This is also what Frances H. Burnett (1906) describes in her famous children's book *A Little Princess*.

> How is it that animals understand things I do not know, but it is certain that they do understand. Perhaps there is a language which is not made of words and everything in the world understands it. Perhaps there is a soul hidden in everything and it can always speak, without even making a sound, to another soul. (Burnett, 1906, ch. 9)

The imprecise sign-based communication we are used to is needed as long as we are not yet ready to, in trusting presence, turn inwards to our innermost shared essence—to the place where no thoughts are private. But by learning to use the words in ways that stimulate trust to flourish, the way is paved for such a transcendent communicative development. This book has hopefully contributed some suggestions as to how this can be accomplished. Once there, not only words but also ethical principles become redundant.

In this chapter, I have suggested that deep sustainability requires a development of consciousness to a more advanced state, and that a precondition is that we let go of projections, concepts, and naming in favor of a direct experience of existence. In 2013, the British newspaper *The Guardian* published an article on Thich Nhat Hanh, entitled "Only love can save us from climate change." In the

concluding section, I will develop some thoughts about how this can be interpreted in communicative terms in relation to deep sustainability.

## Love as Deep Sustainability

Some readers may have wondered why love is not addressed in this book as a given communication-ethical principle to stimulate the reclamation of trust. When I have mentioned love in the previous chapters, I have done so largely in passing and quickly moved on. There is a reason for this. Love is not a component of sustainable communication but is at the same time both the basis for and the result of it. When the experience of separation and duality decreases, the experience of love increases to the same extent, not primarily as an emotion—with which we often associate love—but as the complete lack of distinction toward the "other." Love is "consummated as a purely spiritual awareness, a unitive love-knowledge of the essence of its object" (Huxley, 2009, p. 85).

In our materialist and rationalist society, love has been largely confined to the private or religious spheres. However, many people today feel alienated from the church, perhaps because spirituality has been ritualized to a point where its message is completely watered-down instead of constituting a meaningful and vibrant foundation of everyday experiences. Luckily, there are exceptions to this. Obviously, in the private sphere it is legitimate to practice romantic love for a partner, parental love for our children, and amicable love for our friends, but otherwise love has a hard time getting through in society's various fora.

In the post-truth era, where cynicism and disruptive conspiracy theories thrive in the digitized mediascape, love also seems to have been ascribed a good deal of naivety. In many contexts, it signals weakness and is eclipsed by dualistic rationality or emotionality as well as cynical conflict-seeking polarization. Love has, simply put, been forcefully downgraded among the virtues of society. The search for happiness in the material world, the powerlessness in the face of a world in chaos, the excluding mechanisms of society, and the experience of separation in combination with spiritual poverty have rendered love obsolete.

But love should be seen as an omnipresent unlimited force with unimaginable potential! And love thrives with the growth of trust and the parallel, gradual dissolution of duality. In Hinduism and Buddhism, such liberation from the karmic wheel in the world of opposites is called *moksha*. With the vocabulary of Christianity, the same thing is called *salvation*; we have been salvaged from hell and found heaven because we have seen through the illusion of separation.

Salvation is the undoing of the world of opposites. Liberation, or salvation, stands before us whenever we change our perceptual perspectives and see the world, not with our physical eyes, which are limited to the illusory surface, but with true vision—the boundless heart. In true vision, we recognize that there are no opposites, and we know that everything is One, intertwined and permeated with love. This is the state of consciousness that Jesus referred to as the Kingdom of Heaven (Adyashanti, 2013, p. 203). And, as he repeatedly stated, we do not find heaven anywhere else or at any other time (e.g., Luke 17: 20–21). Heaven is imminent within and among us. Here and now in love.

> Heaven is both within and among us, closer to us than our own heart it permeates everything. At the same time inaccessible, beyond our physical and material universe. The Kingdom of Heaven is visible to us whenever we allow love to take hold in our lives. (Carlsson 2014, August 24, author's translation)

In the *Gospel of Thomas* (113), Jesus says that the Kingdom of Heaven is "spread out upon the earth, and people do not see it." And this is true, when all our attention turns outwards, in agitation confirming and reproducing our flawed perceptions of a rapidly shifting world charged with conflicts and opposites. It is, thus, only when we turn inwards and rest effortlessly and without expectations in the unmoving stillness, joy and trust that are constantly available here, that heaven is revealed to us. As also testified by the *Tao Te Ching*, Tao is "encountered and found *within* us, not outside us" (Wilkinson, 1997, p. xv, italics in original), and Hammarskjöld (1964, p. 152) describes this as follows:

> In the point of rest at the center of our being, we encounter a world where all things are at rest in the same way. Then a tree becomes a mystery, a cloud a revelation, each man a cosmos of whose riches we can only catch glimpses.

It is also from this center of our being that we extend the love of heaven to others, when the most fundamental of all dualisms, the one between fear and love, dissolves. They who have freed themselves from this dualism is "free from the delusion caused by the pairs of opposites," as the *Bhagavad Gita* (7:28) puts it.

Thus, to accept the power of love is to bring the illusory world of opposites to an end. Because when the distinction between subject (perceiver) and object (perceived) collapses, marvelous beauty and the deepest of love appear before us. The Sufi saying "Wherever the eye falls, there is the face of God" refers precisely to this experience. All we see is a single coherent and indivisible Self in which all

seemingly separated forms arise. And this is where we experience "the ultimate reality that transcends all opposites" (Morrison, 2007, p. 179).

The *Declaration of Love*, developed by Erwin Laszlo (2013), defines the power of love in a similar way:

1. Love breaks the illusion of separation between yourself, other people and nature. I am That in my communication and communion with all things that constitute the fabric of life on this planet. I am That with my fellow human beings. We are part of the diversified but basically unified community of life on this planet where everything is interconnected in an indivisible whole.
2. Love provides the knowledge that I am not separated from you. The separate identity that I attribute to other beings is an illusion. There are no others in this world. We are all perfect parts of each other.
3. Love reminds us to become One again. With you and with the world. Love leads to wholeness again, embraces my love for you, for all people and for nature in my thinking, my actions, in my consciousness, so that we can (again) create a civilization on this planet that is worthy of the excellence that is part of us all.

But to overthrow the illusory duality, trust and faith in the power of love are required; trust and faith in a Love that is strong enough to hold us, even if we cannot perceive it through our deceptive senses, which, on the contrary, most often bear witness of the opposite. Ram Dass (2011, p. 158) emphasizes that faith should not be confused with belief, because it is inherent in our innermost essence, in the unmoving being, and that it is precisely trust and faith that connect us with Love—with the absolute Truth.

> Faith is not a belief. Faith is what is left when your beliefs have all been blown to hell. Faith is in the heart, while beliefs are in the head…. The moment you recognize that faith lies behind experience, that it's just *being*, not the experience of being but just *being*, then it's just "Ah, so."

Thus, this unconditional love should not be conflated with the type of love that only benefits a limited number of people. Romantic love, for example, rarely comes without demands, but is, on the contrary, often a misguided attempt to fill a perceived lack in ourselves. The truly unconditional love is all-embracing and always available in our deep Self. It is like the sun that shines on everything and everyone equally. Even if we are not aware of it, we can at any time and

in any situation choose between communicating fear or unconditional love. If we choose the former, we continue to condemn, judge, analyze, attack, defend, manipulate, or demand. We continue to communicate the images of ourselves that we want others to have and hide the ego's peculiarities because we are afraid of not being good enough otherwise. But if we do the latter, communicate love, we embody our innermost being. In every challenging communicative situation, we use our intuitive wisdom and compassion and ask, "What is the most loving thing I can do or say right now?" We wait for the answer from within, listen carefully when it comes and act (or do not act) accordingly (Adyashanti, 2020).

When we choose to end the struggle with ourselves and to fully accept and embrace any experience, we also open to Love in any form it wants to present itself; as compassion, generosity, joy, forgiveness, or as something else that has been suggested (or perhaps not suggested) in this book. This gives us the graceful opportunity to communicatively extend it all to others with gratitude that we are contributing to the healing of what has been perceived as broken and separated. In fact, if we welcome Love, which is inherent to our Self, we will have no other needs but to offer it to others; if we see Love within us, we will see it everywhere, and by offering Love, it will come to us.

What we give comes back to us, and we can always choose to give Love because we realize that what we extend—whether it is fear or love—comes back to us. What we keep in our minds is reflected back to us. In the quotation below, Eisenstein (2011) describes how this reciprocity can be used for a "love revolution," in which the dualistic relationship to the "other" dissolves.

> An economist says "more for you is less for me." But the lover knows that more for you is more for me too ... Your sense of self expands to include other beings. That's love. Love is the expansion of the self to include the other. And that's a different kind of revolution. There's no one to fight—there's no evil to fight. There's no "other" in this revolution.

This reciprocity would ultimately lead the way into the *symbiocene,* a love-based world where every being's symbiotic interconnectedness with the rest of the Earth's inhabitants is not only acknowledged but turned into lived experience (Lent, 2021).

Thus, the revolution is, as Spira (2017) points out, not of the external kind but of the internal. It is quite simply about us awakening and (re)gaining access to the knowledge of *who we really are.* And on this knowledge, all other knowledge must build. This is the single path to deep sustainability and what Thich Nhat

Hanh most likely meant when claiming that "only love can save us from climate change." Life is Love, and life is not something we have but something we *are*.

With this book and the ethics of sustainable communication, I have tried to show that communication indeed is capable of contributing to the growth of trust through *communing*, that is, to (re)establish *communion*—the already existing connections between everything that *is*. The fabric of these connections is not complicated but consists of pure, unconditional love. "True communication is communion—the realization of oneness, which is love," as Tolle (2011, p. 130) proposes. In the transformation to a higher state of consciousness, which implies a new and different worldview, we place our trust and faith here: in Love; in the Indivisible Whole; in Consciousness; in the Now; in the One; in Truth; in our innermost Being; in the Supreme Ultimate; or as Bishop Emeritus Bengt Wadensjö (2014, author's translation) puts it: In the flowing sea of Grace, Peace and Love. If we want to express this with religious terminology, we can say that we place our trust and faith in God (without any anthropomorphizing connotations). The linguistic label—the naming—is not important.

# References

Abram, D. (1997). *The spell of the sensuous: Perception and language in a more-than-human world.* New York: Vintage Books.

Adams, C. J., & Gruen, L. (2014). *Ecofeminism: Feminist intersections with other animals & the earth.* New York: Bloomsbury.

Adyashanti. (2013). *Falling into grace: Insights on the end of suffering.* Boulder: Sounds True Inc.

Adyashanti. (2020). *Making the choice to love* [Video]. YouTube. https://www.youtube.com/watch?v=XqmZ3m3cJi8

Berglez, P., Olausson, U., & Ots, M (Eds.). (2107). *What is sustainable journalism? Integrating the environmental, social, and economic challenges of journalism.* New York: Peter Lang.

Buriti, R. (2019). "Deep" or "strong" sustainability. In W. L. Filho (Ed.), *Encyclopedia of sustainability in higher education.* Switzerland: Springer Nature. https://doi.org/10.1007/978-3-319-63951-2

Burnett, F. H. (1906). Chapter 9: Melchisedec. *A Little Princess.* Lit2Go. https://etc.usf.edu/lit2go/33/a-little-princess/365/chapter-9-melchisedec/

Carbaugh, D., & Boromisza-Habashi, D. (2011). Discourse beyond language: Cultural rhetoric, revelatory insight, and nature. In C. Meyer & F. Girke (Eds.), *The rhetorical emergence of culture* (pp. 101–118). New York & Oxford: Berghahn Books.

Carlsson, O. (2014). *Just idag: 365 tankar för sinnesro* [*Thoughts for the day: 365 Reflections for peace of mind*]. Stockholm: Bonnier Fakta.

Cronon, W. (1996). The trouble with wilderness: Or, getting back to the wrong nature. *Environmental History, 1*(1), 7–28.

Dickinson, E. (2013). The misdiagnosis: Rethinking the "nature-deficit disorder." *Environmental Communication, 7*(3), 315–335.

Easwaran, E. (2007). Introduction. In *The Upanishads* (E. Easwaran, Trans., pp. 13–47). Tomales, CA: Nilgiri Press.

Eisenstein, C. (2011, November 18). *The revolution is love* [Video]. YouTube. https://www.youtube.com/watch?v=BRtc-k6dhgs

Eisenstein, C. (2022, March 13). *My existence is relational* [Video]. YouTube. https://www.youtube.com/watch?app=desktop&v=eK93axLKQUw&feature=youtu.be&fbclid=IwAR2xbvh4vk0e53RranbZ2tV_KOu-chtl0szCegUf5e3ZoJTV629h2sAAii0

Freeman, C. P. (2020). *The human animal earthling identity: Shared values unifying human rights, animal rights & environmental movements.* Athens: University of Georgia Press.

Hammarskjöld, D. (1964). *Markings* (L. Sjöberg & W. H. Auden, Trans.). New York: Knopf.

Hultman, M., Berg, N., Berg, I., & Begovic, H. (2022). *Ecopedagogy for earth rights: Co-creating a vibrant culture of peace.* London: Dixi Books.

Huxley, A. (2009). *The perennial philosophy.* New York: Harper Perennial. (Original work published 1945)

Kemmerer, L. (2014). *Eating earth: Environmental ethics & dietary choice.* Oxford: Oxford University Press.

Kopnina, H. (2019). Anthropocentrism: Problem of human-centered ethics in sustainable development goals. In W. L. Filho, P. G. Özuyar, P. J. Pace, A. M. Azul, L. Brandli, L. Azeiteiro, & T. Wall (Eds.), *The encyclopedia of the UN sustainable development goals. Life on land.* Springer Major Reference Works.

Lazlo, E. (2013, March 28). *A new love declaration* [Video]. YouTube. https://www.youtube.com/watch?v=lkA_ILHfcfI.

Lent, J. (2021). *The web of meaning: Integrating science and traditional wisdom to find our place in the universe.* Gabriola Island, Canada: New Society Publishers.

Macy, J. (2021). *World as lover, world as self: Courage for global justice and ecological renewal.* Berkeley: Parallax Press.

Martin, G. T. (2020). Deep sustainability: Really addressing our endangered human future. In T. K. Tan, M. Gudic, & P. M. Flynn (Eds.), *Struggles and successes in the pursuit of sustainable development.* London: Routledge.

Milstein, T. (2008). When whales "speak for themselves": Communication as a mediating force in wildlife tourism. *Environmental Communication, 2*(2), 173–192.

Morrison, D. (2007). Introduction to chapter 10. In *The Bhagavad Gita* (pp. 179–182). Tomales, CA: Nilgiri Press.

Mouffe, C. (2005). *On the political.* London: Routledge.

Naess, A. (2016). *Ecology of wisdom.* London: Penguin.

Olausson, U. (2005). *Medborgarskap och globalisering: Den diskursiva konstruktionen av politisk identitet* [*Citizenship and globalization: The discursive construction of political identity*] (Doctoral dissertation, Örebro universitet). Örebro Studies in Media and Communication 3.

Olausson, U. (2020). Making sense of the human-nature relationship: A reception study of the "Nature Is Speaking" campaign on YouTube. *Nature and Culture, 15*(3), 272–295.

Olausson, U., & Uggla, Y. (2021). Celebrities celebrifying nature: The discursive construction of the human-nature relationship in the "Nature Is Speaking" campaign. *Celebrity Studies, 12*(3), 353–370.

Pattberg, P. (2007). Conquest, domination and control: Europe's mastery of nature in historical perspective. *Journal of Political Ecology, 14*, 1–9.

Pollan, M. (1991). *Second nature: A gardener's education.* New York: Grove Press.

Ram Dass (with Rameshwar Das). (2011). *Be love now: The path of the heart.* New York: HarperOne.

Singh, R. P. B. (2017). Ecospirituality and sustainability: Vision of Swami Vivekananda. In A. Pradhan et al. (Eds.), *Swami Vivekananda's contribution to India* (pp. 157–168). Varanasi: Pilgrims Book House.

Spira, R. (2017). *The nature of consciousness: Essays on the unity of mind and matter.* Oxford: Sahaja Publications.

Tolle, E. (2011). *The power of now: A guide to spiritual enlightenment.* London: Hodder & Stoughton.

Uggla, Y., & Olausson, U. (2013). The enrollment of nature in tourist information: Framing urban nature as the "other." *Environmental Communication, 7*(1), 97–112.

Valladolid, J., & Apffel-Marglin, F. (2001). Andean cosmovision and the nurturing of biodiversity. In J. A. Grim (Ed.), *Indigenous traditions and ecology: The interbeing of cosmology and community* (pp. 639–670). Cambridge, MA: Harvard Press.

Wadensjö, B. (2014). *Gud: Ett svallande hav av nåd, frid och kärlek* [*God: A flowing sea of grace, peace and love*]. Sandared: Recito.

Wilber, K. (2000). *Integral psychology: Consciousness, spirit, psychology, therapy.* Boston & London: Shambala Publications.

Wilkinson, R. (1997), Introduction. In *The Tao Te Ching* (pp. vii–xix). Hertfordshire: Wordsworth Editions Limited.

Williams, R. (2005). *Culture and materialism.* London: Verso.

# Afterword

"I give you these precious words of wisdom; reflect on them and then do as you choose," are Krishna's concluding words to Arjuna in the *Bhagavad Gita* (18:63). Obviously, the present book does not claim to have conveyed any similar wisdom. I am not even sure that I have fully succeeded in communicating the message I believe that we, for the sake of deep sustainability, are in utter need of: Trust must be up-scaled and separation down-scaled so that we may reach a higher level of consciousness and begin to embrace our true nature—oneness and communion. After all, words are, as we are well aware of at this point, mere symbols and as such very crude tools for communication. My humble wish, however, is that you reflect a moment on those given here, and then do as you choose.

Simon Cottle, General Editor

From climate change to the war on terror, financial meltdowns to forced migrations, pandemics to world poverty, and humanitarian disasters to the denial of human rights, these and other crises represent the dark side of our globalized planet. They are endemic to the contemporary global world and so too are they highly dependent on the world's media.

Each of the specially commissioned books in the Global Crises and the Media series examines the media's role, representation, and responsibility in covering major global crises. They show how the media can enter into their constitution, enacting them on the public stage and thereby helping to shape their future trajectory around the world. Each book provides a sophisticated and empirically engaged understanding of the topic in order to invigorate the wider academic study and public debate about the most pressing and historically unprecedented global crises of our time.

For further information about the series and submitting manuscripts, please contact:

> Dr. Simon Cottle
> Cardiff School of Journalism
> Cardiff University, Room 1.28
> The Bute Building, King Edward VII Ave.
> Cardiff CF10 3NB
> United Kingdom
> CottleS@cardiff.ac.uk

To order other books in this series, please contact our Customer Service Department at:

> peterlang@presswarehouse.com (within the U.S.)
> orders@peterlang.com (outside the U.S.)

Or browse online by series:

> www.peterlang.com

www.ingramcontent.com/pod-product-compliance
Lightning Source LLC
Chambersburg PA
CBHW061719300426
44115CB00014B/2756